LANDSCAPE PAINTING
WITH A CHINESE BRUSH

JANE EVANS

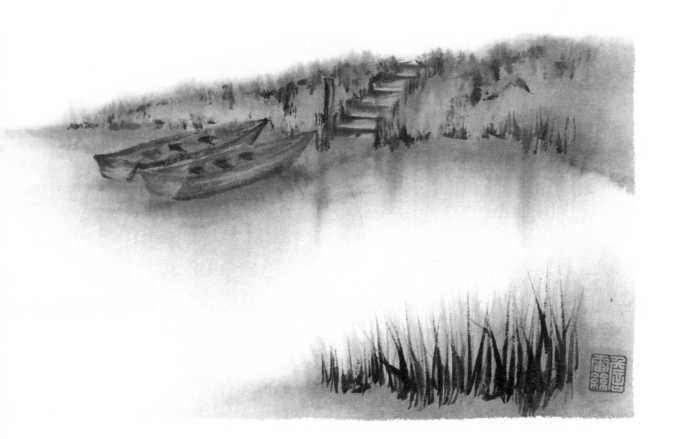

HALF-TITLE: Still water with boats
THIS PAGE: *North Norfolk Coast,*
near Weybourne,
42 × 47 cm (16½ × 18½ in)

LANDSCAPE PAINTING
WITH A CHINESE BRUSH

JANE EVANS

How to Paint
Western Landscapes
the Chinese Way

HarperCollins*Publishers*

For Belinda, in memoriam

First published in 1992 by
HarperCollins*Publishers*
London

© Jane Evans, 1992

Editor: Joan Field
Designer: Caroline Hill
Photographer: Ed Barber
Chinese calligraphy: N. C. Doo
(Chinese Translation Bureau)

A CIP catalogue record for this book is available
from the British Library

ISBN 0 00 412587 8

Set in Goudy Old Style and Optima by
Falcon Typographic Art Ltd, Edinburgh & London
Originated, printed and bound in Hong Kong by
HarperCollins*Publishers*

CONTENTS

内容

A Different Approach

一種不同的處理方法

In writing this book I wanted to offer landscape painters a new way of looking at their subjects, and to tempt them into trying a versatile and expressive medium. I have combined traditional Chinese brush painting methods with newer techniques for which Chinese materials are particularly adaptable. This combination allows me to produce a wide range of effects with which to capture land, sea and sky in their many moods.

The traditional role of a painter

In China, landscape painting traditionally enjoyed a very high status and, with few exceptions, the most admired artists were those who depicted scenes. A formal training in Chinese brush painting is designed to carry the student through different subjects, each of which is both an end in itself and a progressive stage on the way to painting landscapes. One of the reasons for this emphasis was probably because, in the past, in a country whose main philosophies taught the value of withdrawal from daily living, part of the court painters' role was to provide imaginary, contemplative scenes into which busy civil servants could retreat.

These painters were not trying to produce a photographic record of particular places. Rather, they were being true to the Daoist principle of re-creating the spirit or *chi* of what they painted. Lao Tse, the founder of Daoism who was born in 571 BC, believed that everything exists because of a vital life force or *dao*. The *chi* is the manifest form of this and is the power that unites the *yin* and the *yang*, the positive and negative forces whose union creates everything in the universe. Everything, therefore, has to behave according to its *dao*. Traditionally, Chinese brush painters have striven to depict this inner truth of their subjects and have not worried overmuch about strict representation. You can understand, and reproduce on paper, the nature of a cat or a bird without making the picture a faithful portrait.

The same is true of scenery: if the overall impression you receive when looking down into a valley is that of cavernous depth, then it is artistically valid to exaggerate the actual proportions if that is how you can convey your impression of the scene to others.

Thinking about the subject

To paint the pictures in this book, I did not go out with my paints or even with a sketch pad. I tried to absorb the atmosphere of places, to study them carefully, to walk around and look at things from different angles. If possible, I like to get to know a place in different weather conditions and to see it at different times of day. Two people's impressions of the same place will not be identical and even one person's may change according to the season, or even his mood. When I paint a scene, I try to convey my feelings about it and I hope that I interpret an aspect of its essential nature or *chi*.

Once I feel that I have got to know a scene, I return to my studio, often some time later, and try to re-create its atmosphere in my painting. However, I do not have the Chinese insouciance about physical accuracy and my memory is not wonderful, so I do take photographs – not as direct models in place of sketches but as memory triggers. If I am painting a bridge, for example, it can help me to understand its nature if I can remember what it links together. If I am painting Ely Cathedral from one angle, I like to have reminders of what it looks like from the other side. If you use photographs, do not try to reproduce them

Ribblesdale, Yorkshire,
35 × 65 cm (13¾ × 25½ in)
After a week of chill winds, I came on this calm scene during a late afternoon walk in very early spring. I painted the sheep with a technique similar to the one I used for the horse and rider in
Fig. 56.

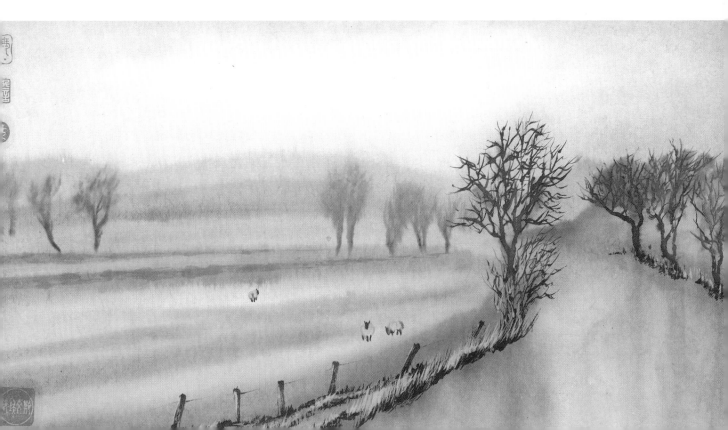

too literally in your painting. Remember that the painter's role is to interpret where the photographer records.

Perspective, light and composition

Chinese landscape painting has conventions that are different from those more familiar in the West and, by taking what I want from both traditions, I feel I have greater freedom of expression in my interpretation of each scene. Western landscape paintings tend to be wider than they are high; in fact, the term commonly used to describe the proportions of such a picture, regardless of the subject, is 'landscape'. Chinese landscape paintings are often higher than they are wide, or 'portrait' shape. This probably results partly from the traditional method of mounting paintings on scrolls. There is also, however, a secondary tradition of narrative scrolls which has produced many discursive landscapes of far greater width than depth. Whichever way they are done, the difference in length between the longer and shorter sides can vary greatly from picture to picture.

Let your scene determine which way you turn your paper, and let the subject, not your piece of paper, dictate the size and shape of the painting. I always begin with a sheet that is bigger than I think I shall need. This gives me the freedom to allow my subject to expand to a natural boundary.

Traditional Chinese landscape painters have treated perspective differently from their Western counterparts, although contemporary Chinese painters do often adopt vanishing-point perspective. The Chinese convention is for a landscape to be depicted as if the middle ground and the distance have been tilted up so that they are higher than the foreground. Landscapes are always divided into these three elements, which are differentiated by varying tonal values.

The elements of a Chinese landscape are not necessarily all viewed from the same angle. Trees and people, for example, are usually depicted from the side, but buildings are normally painted from above. Thus the artist is freed from the constraints imposed by a single viewpoint. A Chinese brush painter may also change the light source so that each element is lit in a way that enhances its individual nature or *chi*.

When I paint a landscape, I usually use Western concepts of perspective and light sources. However, I normally incorporate the three elements of foreground, middle ground and distance, although I may not make the foreground the main feature of the picture, as it usually is in a traditional Chinese landscape. In the painting in

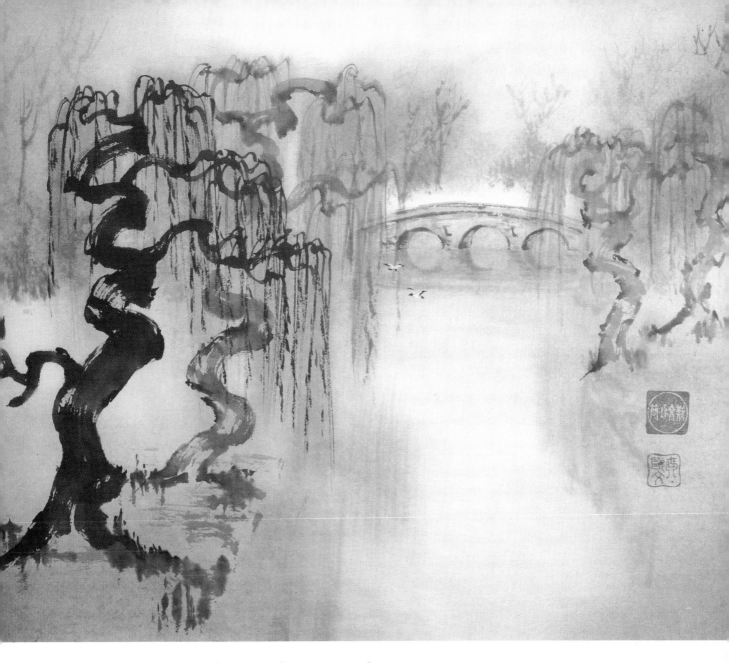

Fig. 1, it is the bridge that gives the picture its location and this is in the middle ground. I also find that I am freer to re-create my impression of a place if I can sometimes alter the viewpoint. By looking at the main willow tree as I have depicted it in **Fig. 1**, my view of the bridge was obscured by the tree. I have used artistic licence to portray the bridge from one angle and the tree from another. Nevertheless, people who know the scene well usually recognize it in my painting and regard it as a realistic portrayal of Trinity College Bridge on the kind of dank, misty winter's day that Cambridge specializes in (see also page 98). Few people look at a scene by standing in one spot. They move around and their impression of the scene and their memory of it is a distillation of all their viewpoints. Unlike the photographer, the painter is free to express a more complete impression of the nature of a place.

Fig. 1 *Trinity College Bridge, Cambridge,* 45 × 56 cm (17¾ × 22 in)

Approach to painting

A watercolourist has to begin with washes and then fill in the distance before working on the foreground of his landscape. However, because of the properties of Chinese painting colours, ink and paper – which are discussed in detail on pages 17 to 22 – the Chinese brush painter is free to begin with the main element of his painting, the foreground, and work back into the distance. The washes are painted last of all.

I never begin a painting with a preliminary sketch. This would be contrary to the traditions of Chinese brush painting and an immediate constraint on my freedom of expression. The spontaneity that can be achieved by working directly with brush strokes is one of the chief attractions of the medium. Landscapes are usually begun by brushing in all the tones in grey and black ink before any colour is added – a convention that I usually follow.

For the paintings in this book I have used a foundation of traditional Chinese brush painting methods, materials and conventions. To this I have brought a Western way of looking at things and an open-minded approach to technique. I hope the results will stimulate you to try Chinese brush painting techniques in your own work.

(OPPOSITE) *Cheddar Gorge, Somerset,* 74 × 48 cm (29 × 19 in)
I wanted a splash of colour in this painting and so I changed the tent from dirty white to orange. I also made it a more typical tent shape. I blended Chinese mineral blue into the deepest shadows and on to some of the foliage. To convey the slightly ghostly effect made by the trees against the top of the rockface, I painted them in gouache white, untouched-up with black.

Materials & Equipment

材料及設備

BRUSHES

You cannot do Chinese brush painting unless you use a Chinese brush. This is made differently from a Western brush. Instead of clamping bristles into a metal ferrule and only then trimming the hairs to shape the head, as is done in the West, a Chinese brushmaker first selects carefully graded hairs, glues them together at their base to make the characteristic pointed brush-head, then glues the head into the handle. This method of manufacture results in a highly versatile and adaptable brush. The density of the bristles in the heel means that the brush will hold a great deal of moisture: ink, colour or just water. Also, it can be loaded with more than one tone or colour at once, allowing you to achieve a subtle blending of tone with a single stroke, thereby adding spontaneity and vigour to your painting. Because you do not need to keep refilling the brush with ink or colour you can maintain the momentum of your brush strokes.

The shape of the brush-head allows you to produce many different widths of stroke with the same brush, from as fine as a hairline to as wide as the bristles of a particular brush are long. The head of a Chinese brush can be splayed out or twisted to give a variety of split-brush or feather-stroke effects. By varying the pressure and angle of your brush as you use it, you can create expressive strokes whose shape and texture add interest and form to your paintings.

Chinese brushes come in three main varieties: soft, firm and coarse (see **Fig. 2**). Soft brushes are usually white and are made from sheep or goat hair. Firm brushes, usually light brown, may be labelled 'wolf' or 'fox' hair but can be made from the hair of a variety of animals, often weasels or small rodents. Coarse brushes may be very dark brown, light brown or greyish black and generally are made of horse hair. This categorization of brushes is a general guide; it is not an absolute rule as hair type and colour can vary.

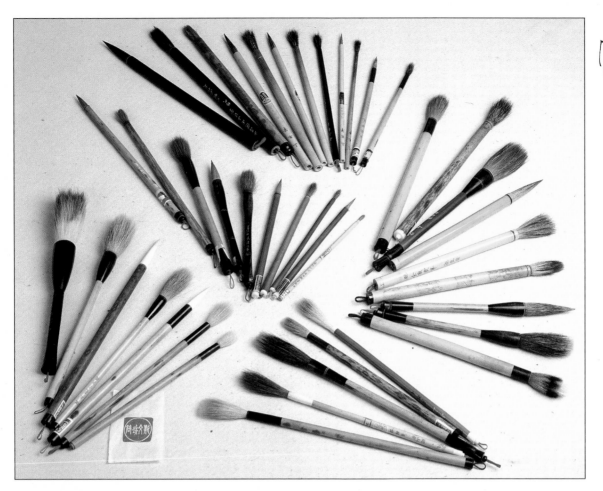

Fig. 2 Painting brushes:
(clockwise from the chop) soft,
firm, coarse, mixed hair and hook

Soft brushes come in a wide range of sizes, although it is
unusual to find a really small one because these can be used
only for fine line work, for which soft brushes are not very
suitable. The smallest normally sold has bristles 1.5 cm
(⅝ in) long with a diameter of 0.5 cm (³⁄₁₆ in). By contrast,
it is possible to find enormous soft brushes – larger than any
available firm or coarse brush. I have one that is 9 cm
(3½ in) long with a diameter of 4 cm (1½ in) and I have
seen them much bigger than this.

The softer a brush is the more it responds to pressure.
Some artists claim that soft brushes are the most expressive.
However, they are also the most difficult to control since,
once applied to the paper, they bend and splay out after
a single stroke, whereas firmer brushes spring back into
shape. Soft brushes are very useful if you want to apply
a whole brushload in a single, slow, pressed-down and
sometimes twisted stroke, and when you are applying colour
and want it to bleed outwards from your brush. They can
produce very expressive lines and, when you grow more
confident of your technical ability, you will be able to use
them to tackle trees and grass.

Firm brushes spring back into shape after each stroke. They are the best kind of brush for producing fine, even lines and they can also create controlled feathered strokes where the brush is gently splayed before it is applied to the paper. These are really the basic and most adaptable kind of brush and, for most sorts of Chinese brush painting, a selection of different sized, good quality, firm brushes is all that you need. I tend to use firm brushes mainly when I want crisp, clean, well-shaped strokes.

It is possible to buy extremely small firm brushes, as small as 0.5 × 0.25 cm (³⁄₁₆ × ³⁄₃₂ in), which can really be used only for fine line work. Although they are made, firm brushes are not usually supplied in very large sizes, probably because these would be so expensive. The largest easily available is about 3.5 × 1.5 cm (1³⁄₈ × ⁵⁄₈ in).

Coarse brushes come in a wide variety of sizes and shapes. The stiffest, spikiest horse hair brushes tend to be longer and narrower at the base than soft or firm brushes. The ones I have range in size from 2.5 × 0.5 cm (1 × ³⁄₁₆ in) to 6 × 1.5 cm (2³⁄₈ × ⁵⁄₈ in). Other horse hair brushes are more like firm brushes in shape; that is, they are fatter at the base and taper more to their tip. Mine range in size from 2.5 × 0.75 cm (1 × ¹⁄₃ in) to 5 × 2 cm (2 × ¾ in). These spikey brushes are wonderful for creating exciting, rough-textured strokes.

Some brushes are made of a mixture of firm and soft hair or firm and coarse hair. I refer to these as semi-soft and semi-coarse.

With the exception of the very coarse horse hair brushes already mentioned, most Chinese brush-heads have a standard characteristic shape. However, there are some soft and firm brushes which are shorter and fatter than normal and others that are longer and thinner. The short fat ones hold a great deal of moisture and are occasionally useful for applying colour. The longer, thinner ones are sometimes called hook brushes. Occasionally, you can buy very long, thin Chinese brushes made of soft, firm or coarse hair. Although these are difficult to control they are capable of very expressive strokes.

I use two wash brushes (see **Fig. 3**): a 4 cm (1½ in) Chinese hake and a 2.5 cm (1 in) one. You can also use Japanese hake brushes. I do not recommend your using one that is wider than 5 cm (2 in) because you would find it more difficult to control the colour while you spread it.

A lot of brushes sold as 'Chinese' in Western art shops are, in fact, Japanese. They are made in the same way as

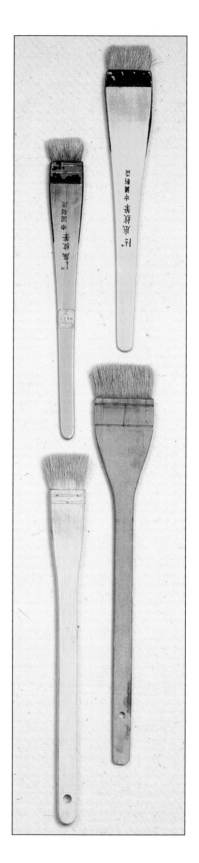

Fig. 3 Chinese (TOP) and Japanese (BOTTOM) wash brushes

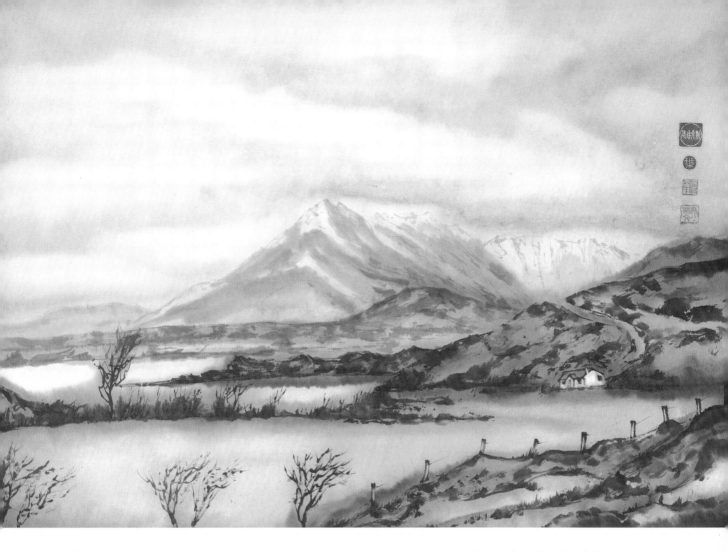

the Chinese ones but the hairs tend to be less densely packed at the base. Some Japanese brushes are good but my colour guide to firmness is less reliable in this case as the light brown ones tend to be rather soft. The coarser-haired ones, however, do make an acceptable substitute for the harder-to-come-by Chinese horse hair brushes. Whatever kind of brushes you buy, it is worth getting good-quality ones. If you use a poor brush you will need much better technique to achieve the effects you want.

When they are new, Chinese brushes are coated in size which keeps the bristles in the characteristic pointed shape – an unsized brush will come to a point only when it is wet. You must thoroughly wash off the size with cold water before using the brush. Sometimes, when you have washed the brush, you discover that it is packed with inferior hair in the centre. Generally, the price and the knowledge of the supplier are your best guide to choosing brushes. Allowing for size, the more expensive the brush the better it will be. It is preferable to have a few good-quality brushes than a great many poor ones. Try to buy, if possible, from one of the growing number of specialist shops; some of them are listed on page 144.

The Cuillin Hills, Isle of Skye, 70 × 100 cm (27½ × 39½ in) I make no apology for the large number of Scottish scenes in this book. I was overwhelmed by the beauty of the Western Highlands in early spring and found the Isle of Skye stunning. This view of the Cuillins seen from southern Skye was painted on Taiwanese *shuan*. The paper shows ink tones and colours very crisply but allows them to run easily. I worked the land very fast in dry ink and then took advantage of the paper by doing a very loose wash, encouraging the colour to run.

Many Chinese brushes come supplied with clear plastic or bamboo caps. The brush-head will expand slightly once the size has been washed off. Putting the cap back on will therefore damage the bristles.

Always wash your brushes in cold water immediately after use, and pat them gently dry with tissue before hanging them up. Most Chinese brushes have a small loop at the end for hanging them head downwards to dry. Because the bristles are held together, and in the haft, with glue, never up-end brushes in a pot to dry because water will seep down into the base of the bristles and undermine the glue. The Chinese make special brush hangers (see **Fig. 4**). Before I had one of these I used to hang my brushes from paper clips hooked over a piece of string. If you take care of your brushes, they should serve you well for years.

To transport brushes, roll them in a slatted bamboo mat. This will be kind to the bristles and allow your brushes to dry naturally after use. Never use one of the plastic brush carriers sold in art shops.

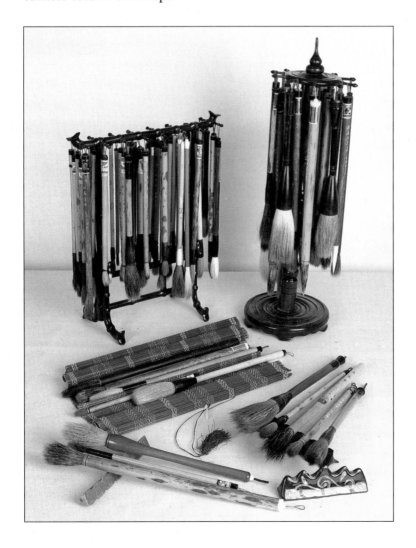

Fig. 4 Brush hangers and rests, with a bamboo mat for transporting brushes

In addition to my basic Chinese brushes, I occasionally use other means of applying paint to paper such as sponges of different textures and sheets of plastic. Many non-brush methods of applying ink and colour are time-honoured in Chinese painting tradition.

PAPER

Texture and effect are, of course, created by the reaction between the brush, the ink or colour and the paper, so it is important to choose the right kind of paper for your painting. Many of the effects in my pictures are the result of the absorbency of the paper used. The ink and colours sink into the paper and bond with it, so much so that many paintings are as clear on the back as on the front.

Contrary to popular belief, Chinese painting paper or *shuan* is not normally made of rice straw but a mixture of bark and grass, although until recently bamboo pulp was believed to make the best painting surface. *Shuan* paper varies considerably in quality and texture and in the way paint behaves on it. Generally, the higher the proportion of bark the better the paper. Because it is hand made it occasionally has faults and inconsistencies but it is often possible, with practice, to turn these to your advantage. Some *shuan* is very thin and delicate and some is thick and

Knock Castle, Sound of Sleat, Isle of Skye, 46 × 95 cm (18 × 37½ in)
To convey the way that the castle stands out against the distant mountains and the sea, I have emphasized it by making it slightly larger than life and using very black ink.

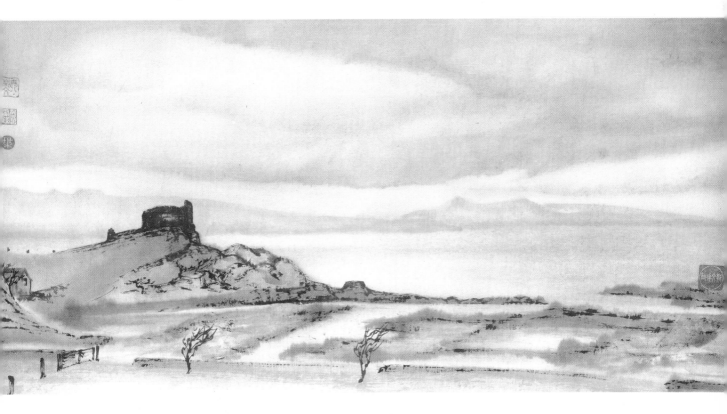

robust. On some papers paint will spread very rapidly; on others it will scarcely spread at all. Some papers are sized to make them less absorbent and, in the past, painters used to size their own paper with alum or glue. Nowadays, you can buy it ready sized. Paper which is smoother on one side than the other has had size applied. To take advantage of the sizing, paint on the smoother surface.

The different characteristics of the various papers become apparent only when you use them. I find that one of the exciting things about Chinese brush painting is adapting my technique to make full use of the particular qualities of the paper. Unless I am painting a very large picture, in which case I need to buy paper in individual, large sheets, I normally prefer to use unsized, hand-made *shuan* of the kind that is sold in ten-sheet rolls of varying widths. This is easy to obtain and reasonably cheap, so I do not mind tearing it up and starting again if I have to! The quality is fairly consistent from roll to roll; the paper is thick and strong, and very good-natured about being repeatedly damped or crumpled up and reflattened. Occasionally, I use cotton paper or linen paper, both of which are stronger than *shuan* when wet, and come sized or unsized. You can also buy paper made entirely of grass, which is easy to use and an interesting off-white colour, but not very strong.

Many Western art shops sell rolls of machine-made Chinese or Japanese paper which is sometimes called moon palace paper. If you cannot find any other kind of oriental paper, you can use this, but it does not take as kindly to being worked on wet as does the *shuan* because it is easily torn, and this can inhibit your painting style. It is also harder to achieve an evenly blended wash because this paper has a tendency to pill very easily. Nevertheless, you

The US Capitol, Washington DC, 48 × 74.5 cm (19 × 29½ in)
To create the effect I wanted for the building, I kept the paper lightly damped, respraying it when necessary. I usually work skies in colour wash only. Here, however, I ink-washed the sky as well as the land before adding colour, to emphasize the whiteness of the building.

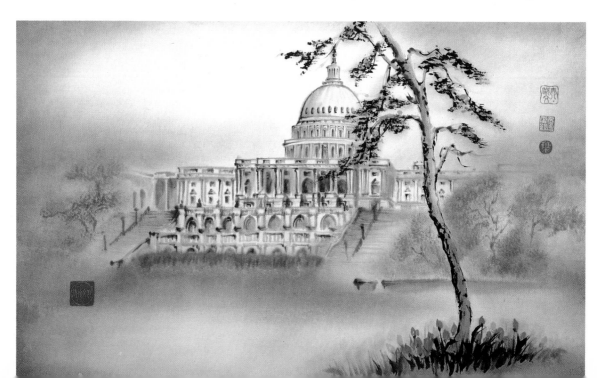

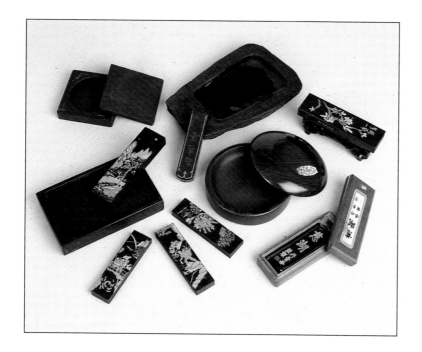

Fig. 5 A selection of ink stones and ink sticks

can use it, with care, for most of the effects I have used for the paintings in this book, although it will not work for the crumpled-paper technique described on pages 83 and 86. Machine-made paper is usually sized on one side, sometimes quite heavily. You will need to paint on the rougher side to achieve the more blurry effects.

INK

Traditional Chinese brush painting is based on the use of ink. Western landscape painters often eschew the use of black because colours that appear to be black are in fact often created by very dark tones of the blues, greens and browns that predominate in nature. Chinese brush painters, on the other hand, use varied shades of ink to provide a full range of tonal values. Many kinds of brush painting use very little colour, or none at all. By skilful manipulation of the tones available to them, artists can convey to the viewer an infinite variety of shades of every colour. I do use colour in my landscape paintings but I often rely on ink for tonal variation, reserving the colour for washes and highlights.

Chinese brush painting ink normally comes in the form of a solid stick made of soot and glue (see **Fig. 5**). To reconstitute it into liquid ink the stick is ground on an ink stone with water. Ink sticks are normally made of either pine soot, which produces a pure black ink, or lampblack, which may produce grey- or brown-toned ink. Ink sticks

vary in quality – price is a fairly good guide although, as with brushes, it is influenced by size as well.

Chinese ink sticks are usually oblong, although they can be cylindrical. They are decorated and often gilded, some of them very elaborately, with Chinese characters and pictures. Japanese sticks are usually oblong with a slightly domed top; they are more simply decorated, usually with only characters, and tend to vary less in quality; they sometimes have a quality star marking on the top.

Ink stones, which are normally made of slate, also vary in price, size and quality. The best stones, which are supposed to come from Guandong and Anhui Provinces in the south and east of China respectively, grind the ink to a fine, even consistency. Most shops that sell equipment for Chinese brush painting stock perfectly adequate, reasonably priced stones. Two kinds are widely available; oblong stones that have a grinding surface and a well at one end to collect ink; and circular ones which usually have a lid to keep the ink moist. Buy as large a stone as possible, so that you can grind a useful amount of ink at a time.

Ink is ground by putting a small amount of water on to the stone with a brush or dropper and grinding the stick with a firm circular movement until the water has absorbed as much ink as it will take. The stick begins to leave dry patches on the stone when this has happened. The stick should not be dipped into a pot of water as this may cause it to crumble. The wet stick should never be left in contact

Clare Bridge, Cambridge,
48 × 61 cm (19 × 24 in)
Clare College bridge in Cambridge is chiefly renowned for the apocryphal tale of a nineteenth-century undergraduate who rode hell for leather from London to Cambridge one night after wagering a large sum of money on the number of stone balls atop the bridge. On finding that he had underestimated, he set about trying to remove one of the surplus balls. The only circumstantial evidence for this tale is that one of the stone balls has a sawn-off section. However, he must have been very drunk because the section in question is on the river side and can be felt only by leaning round.

I used Taiwanese cotton paper for this painting because I hoped its whiteness would help to create the impression of snow. I enhanced the snowy effect by bleeding neat Chinese white on to parts of the ground and by picking out areas of tree and building with white. The main wash colour is a mixture of indigo, autumn brown and peony purple

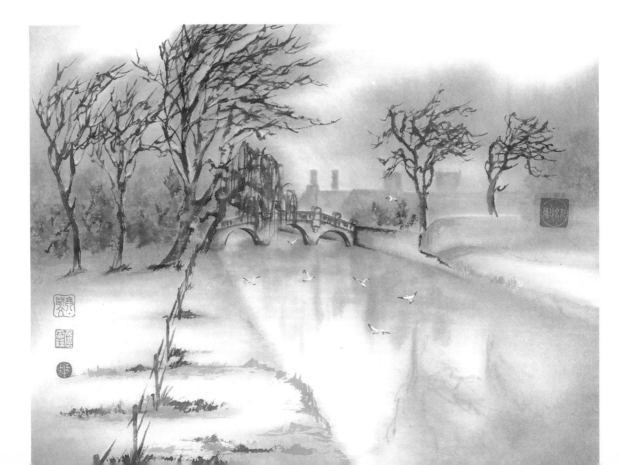

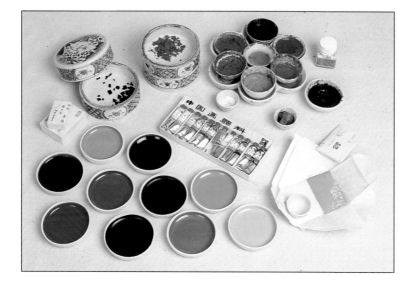

Fig. 6 A selection of painting colours

1 Japanese Teppachi colours
2 Boxes of Chinese colour chips
3 Stacking paint jars with loose Chinese colour chips
4 Chinese chip colours and powder colours reconstituted into solid blocks
5 Chinese rattan yellow
6 Set of twelve Chinese painting colours
7 Chinese mineral green powder
8 Gouache white

with the grinding surface because, in a surprisingly short time, the glue in the stick will fasten it firmly to the stone and you may break the stick or chip the stone getting it off again. Dry the stick in the air before putting it away. It is important to keep your ink stone clean: a build-up of old ink or dust on the grinding surface will make it difficult to grind clean, pure black ink.

It is possible to buy liquid ink in bottles or tubes but I do not recommend this for several reasons. Firstly, the act of grinding the ink before you begin to paint loosens your arm and shoulder and gets you into a calm frame of mind. Secondly, the liquid ink is usually too runny and harder to work with than thickly ground ink. Finally, and perhaps most importantly, the liquid ink contains less glue than an ink stick. Instead it contains preservative. As a result the liquid ink may not bond properly with the paper and sometimes runs when a wash is added.

COLOURS

The Chinese talk about the four treasures of painting: the brush, the paper, the ink stick and the ink stone. Probably colour is not included because Chinese brush painting comes from a strong tradition of calligraphy. Also, there were several 'schools' of Chinese painting that used no colour, or only light washes. Nevertheless, traditional Chinese pigments provide a range of wonderfully varied colours: bright, translucent reds, yellows and blues; opaque, distinctive greens and blues, and many subtle hues. Many Chinese artists have used these and we can exploit their full expressive potential (see **Fig. 6**).

Chinese painting colours are made from minerals and vegetable extracts. The mineral colours come as powders which have to be mixed with book-binding glue to create a solid block of colour. The vegetable dyes normally come as chips of colour already containing glue and these need to be melted down into blocks with hot water. Once the blocks are made, they need to have water added to them about 15 minutes before use, to make the paint into a viscous liquid. Rattan yellow comes in uneven, solid lumps of varied sizes. To use it, you simply pick up colour straight from the lump with a moistened brush.

Widely available now are boxes of tubes of Chinese painting colour which can be used straight from the tube. Many people prefer to squeeze out their paint into small dishes or the compartments of an ice-tray. The water content dries out but, because of the glue, the colour forms a solid block which can then be used by adding a little water before starting to paint.

Japanese painting colours are sold in blocks, either in individual dishes or in boxes of several colours. They are slightly more moist than Chinese colours and do not need water added to them before use. For landscape painting, the dishes are easiest to use because they are big enough to allow you to fill a large brush straight from the dish.

Chinese and Japanese painting colours differ from watercolours partly because of their glue content. This helps them to bond with the paper and makes it possible to put a wash over something you have already painted. Gouache or tempera colours will also allow this but these are opaque. Most Chinese painting colours are translucent; only the distinctive greens and some blues have white added to them. I use gouache paint when I want an opaque tone not available in Chinese or Japanese colours. In the unlikely event of your being unable to find proper Chinese or Japanese colours, it is better to use gouache than to risk unwanted colour runs with watercolours.

OTHER EQUIPMENT

Chinese brush painting is done on a flat, horizontal surface, large enough to allow you to spread out; if you feel cramped then this may be reflected in your paintings. Ideally, the table should be high enough to let you work standing most of the time, so that you can wield your brush freely from the shoulder. If you do not feel able to stand, select a lower table so that your arm movements are not inhibited. It is vital to paint in a good light, preferably daylight.

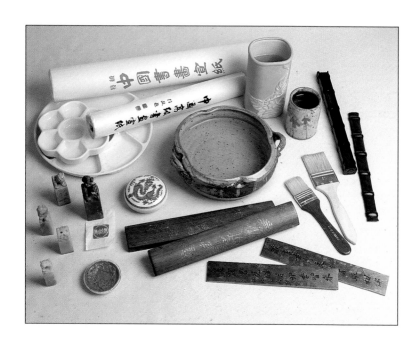

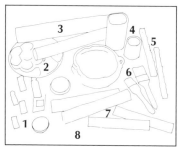

Fig. 7 Other equipment for Chinese brush painting

1 Chops and cinnabar paste
2 Fondue plate and lotus palette
3 *Shuan* paper
4 Water pots
5 Paperweight containing paper knife
6 Mounting brushes
7 Two pairs of paperweights
8 Chinese painting felt

You will need some absorbent padding between the table and your painting – special Chinese painting felt, any thick felt or even an old blanket will do; several water jars; a roll of toilet or kitchen paper; and weights to keep your paper flat while you are working. The Chinese make long thin weights specially for painters and calligraphers (see **Fig. 7**). You should have a white ceramic palette with large sections. Non-white ones make it difficult to judge colour tones and plastic or metal ones do not mix the colours well or come clean easily. A fondue plate with different sized sections, sold in china and kitchen departments, is ideal. A special mounting brush is necessary for backing your paintings, to stretch and strengthen them ready for framing (backing paper is discussed on page 138).

You may like to sign your paintings with a chop or seal. This is a stone or bone block carved with the artist's name, or perhaps a favourite phrase, in seal script. You can either have a chop specially carved or you can select a symbol with a suitable meaning from pre-cut ones. Seal ink is usually red cinnabar paste. The chops that you see on old Chinese paintings may have been put there by the artist, but many were added by critics or collectors.

Where I place my chops on a particular painting is determined by the composition and I think carefully about this, although I am not very good at placing them straight! I sometimes use one to provide an accent of colour. I have several chops which were designed for me by one of my Chinese teachers.

BASIC TECHNIQUES

基本手法

Chinese painting developed over centuries independently of Western art. It drew its aesthetic and compositional values from the philosophies of old China and evolved a rich and diverse technology of its own.

Since Chinese brush painting techniques form the foundation of my work, and because rules can be broken creatively only when they are fully understood, you will need to master basic brush painting techniques before you can adapt them to develop your own style.

THE BRUSH

The skill of a Chinese brush painter is dependent on his ability to manipulate the brush and to exploit its versatility. A Chinese brush that is used incorrectly is very difficult to control; held, loaded and used in the right way, it is a highly effective tool.

Holding the brush

Successful brush painting depends on developing a harmony with the brush and manipulating it so that it does the work for you, creating the effects you want and allowing you to achieve free, vigorous and expressive strokes.

Fig. 8 shows the brush being used at several angles. The basic method is the same for all of these: hold the brush loosely between the thumb and the middle finger; rest the index finger lightly above the middle finger, and the ring finger behind the brush, with the little finger tucked behind. This will give you 360-degree control and enable you to wield your brush at any angle. How high up the haft you hold the brush varies according to the stroke. The easiest brushes to manipulate are firm ones and I suggest that you use one of these while you are familiarizing yourself with the basic techniques. Always use a brush that is large enough to achieve the effect you want in as

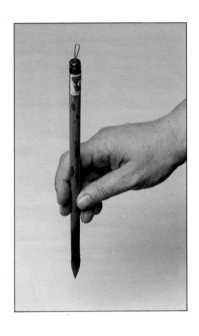

Fig. 8a Basic brush hold

few strokes as possible. For all the basic exercises described below I used a brush with a head 4 cm (1½ in) long and 1 cm (½ in) wide. A firm hair brush of this size is called a bamboo brush because it is ideal for painting bamboo. It is also useful for landscape painting because it is large enough for big, sweeping strokes and firm enough for precise details.

Loading the brush

Because of the way it is made, a Chinese brush holds a great deal more liquid than a watercolour brush. It is important to learn how to load it so that the brush-head holds as much or as little moisture as you need. The heel of the brush can act as a reserve tank for ink, colour or water. This allows you to make a number of strokes without reloading. For fine details, dry the heel of the brush on a tissue before picking up ink with just the tip.

First grind some ink and mix some of it with a little water on your palette to make a reasonable quantity of grey ink. Do not make it too watery. Take a clean dry brush and immerse it fully into the ink so that it soaks up as much as it will hold. Place the full length of the brush-head on to some paper and experiment to see how far you can continue a stroke without reloading. Now wash the brush and reload it. This time, wipe off the excess moisture on the side of your palette before trying the same thing again.

Wash the brush again and, without drying it, dip the top half of the bristles into the ink. Try a stroke using the inked portion of the bristles. You will find that the water in the heel of the brush runs down into the inked part, diluting the ink, furring the stroke and making it go further.

Rewash the brush and dry it gently on a piece of tissue before dipping the top half of the bristles into the ink. This time your stroke should not be diluted and spread by water from the heel.

Try the same thing again, this time dipping only the very tip of the brush into the ink. You will find that with a dry brush you can achieve a much finer, cleaner line.

Any stroke can be made with a wet or a dry brush, depending on the effect you want, but because the paper is so absorbent, you cannot rely on using a dry brush to achieve crisp strokes. A dry brush will add texture, and 'flying white' where the ink misses. To make a crisp stroke with no 'flying white' you need to work fast with a fairly wet brush. Try the strokes in the following sections with different amounts of wetness to discover some of the possibilities for texture.

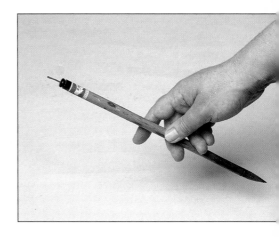

Fig. 8b Correct brush hold gives 360-degree control

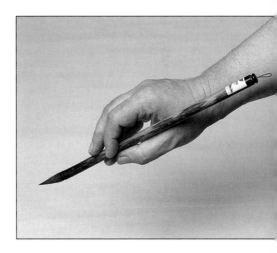

Fig. 8c Tapering a stroke

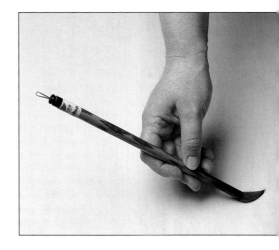

Fig. 8d Using the brush across the bristles

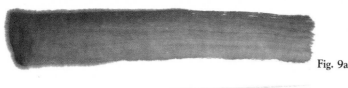

Fig. 9 Different width brush strokes

Fig. 9a

Fig. 9b

Brush angles and pressures

Fig. 9 shows two strokes made with the bamboo brush. Immerse the brush-head fully into light ink and wipe off the excess liquid on the side of your palette. Make stroke **a** across the bristles with the brush-head at right angles to the stroke and the whole of the head pressed on to the paper. Make stroke **b** along the bristles with the brush-head and haft in a straight line with the stroke. Only the very tip of the brush should be in contact with the paper. Work both strokes fast to minimize blurring.

Between these two there is an infinite variety of strokes which can be created by altering the angle of the head, the amount of brush-head in contact with the paper, the pressure of the brush and the amount of liquid it holds. Very seldom will you need to use a stroke which has an even pressure and a uniform angle. A Chinese brush is very expressive if used with skill and confidence, and I urge you to practise until you can produce vigorous, lively strokes.

Fig. 10 Varying the pressure of the brush

Fig. 10a

Fig. 10b

Fig. 10c

Fig. 10d

The illustration in **Fig. 10** shows the effect of varying the amount of brush-head in contact with the paper during a stroke. Make stroke **a** with a continuous, fluid movement along the bristles, keeping the speed constant. As you move the brush, alternately lift and lower it. Stroke **b** shows the same process with the brush used across its

bristles at right angles. For **c** hold the brush-head at an angle of about 45 degrees. These three strokes are made without altering the angle or speed of the brush as you work. However, in **d** you can see the effect of combining changes in pressure with alterations of the angle of the head during the stroke. The branch was painted in a single movement, varying the angle of the head and pressing down at the joints. The strokes shown in **Fig. 10** were all made with the brush-head fully loaded with ink as for **Fig. 9**.

Fig. 11 shows a branch, similar to the one in **Fig. 10d**, painted with a much drier brush. Texture is created by the 'flying white' where the ink missed the paper. Load the brush as before but wipe off more liquid on the side of your palette and then gently dab the brush on to kitchen paper to mop up some of the moisture before you use it.

Fig. 11 Using a drier brush

Fig. 12 Blunt strokes

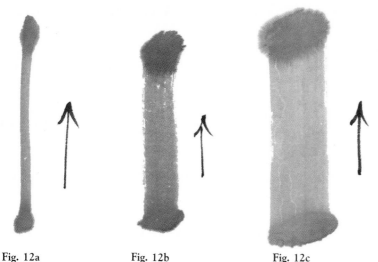

Fig. 12a　　　　Fig. 12b　　　　Fig. 12c

Blunt and tapered strokes

Regardless of the angle of the brush-head, strokes can be blunt or tapered. For the stroke in **Fig. 12a** place the tip of the brush on to the paper and press down slightly. Working along the bristles, move the brush briskly in the direction of the arrow, then pause and press down lightly at the end. Stroke **b** is made in the same way, this time working across the bristles with the head at right angles to the stroke and using the top third of the bristles. Stroke **c** is also made at right angles but this time using the full length of the bristles. A stroke that is blunt at both ends is sometimes called a bone stroke and is similar to the one used to form the segments of a bamboo stem.

Illustrated in **Fig. 13a** is a narrow stroke made along the bristles, using just the tip of the brush. To achieve the tapered effect at each end begin and finish the stroke in the air. Bring the brush down on to the paper, move it along in the direction of the arrow, and lift it off the paper in a single, fluid, evenly paced movement. The tapered stroke **b** is made across the bristles, using the top third of the brush-head.

Fig. 13 Tapered strokes

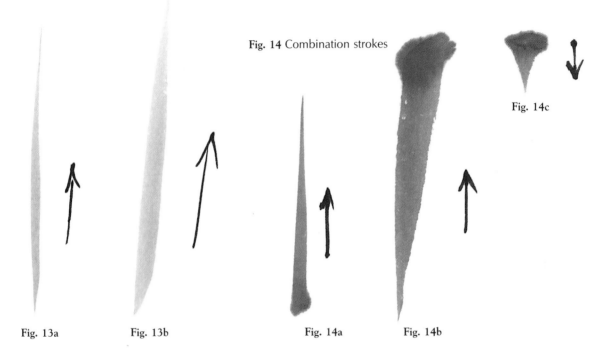

Fig. 14 Combination strokes

Fig. 14c

Fig. 13a Fig. 13b Fig. 14a Fig. 14b

Fig. 14 shows a series of strokes, blunt at one end and tapered at the other, made by combining the methods described for **Figs. 12** and **13**. Make stroke **a** along the bristles: press down lightly to blunt the beginning of the stroke and then taper the end. Stroke **b** is made across the bristles; this time bring the brush down on to the paper to taper the start of the stroke and finish it by pressing lightly. Stroke **c** is also made across the bristles. Begin by placing the brush and pressing lightly on to the paper. Instead of then continuing the stroke, immediately taper it off the paper into the air.

Fig. 15 shows a bamboo leaf stroke painted along the bristles with both ends tapered. As you apply the brush, increase the amount of head in contact with the paper until the whole head is being used, then lift it gradually away. Keep the speed and pressure constant and work fast.

Fig. 15 Bamboo leaf stroke

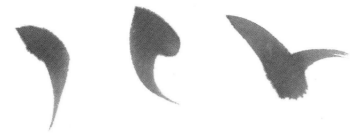

Fig. 16 Altering the brush angle

Essentially the same method is used for the strokes in **Fig. 16**, but for these, turn the brush, altering the angle of the head as you bring it down on to the paper, or as you lift it off, or both.

Split-brush and pushed strokes

You can twist or split the bristles of a Chinese brush and they will stay put. For the stroke in **Fig. 17** fill your brush with ink and wipe the excess off on the edge of the palette as usual. Splay out the tip of the bristles by pressing the brush lightly against the palette surface. You should not have your brush too dry for a split-brush or feathered stroke because it is the splaying of the head that provides the texture here, not the dryness of the brush. If you want the split-brush effect to be more ragged, twist the bristles slightly before you splay them out. Split-brush strokes can be blunt or tapered, depending on the effect you want.

Until now all the strokes I have demonstrated have been made by pulling the brush either along its bristles or across them at an angle. **Fig. 18** shows a stroke made by pushing the brush against its bristles. This is another way of creating texture and shape.

Soft and coarse brushes

Once you have got used to a firm brush you can try using soft and coarse ones. Soft brushes are very expressive but they do not spring back into shape so readily as firm brushes and they are liable to split of their own volition.

Coarse brushes give a twisted or split-brush effect of their own accord and it is more natural and free than the one you achieve with a twisted firm brush. Coarse brushes also create wonderful ragged effects with pushed strokes.

If you want to practise the same style or achieve a similar effect to mine, try to use a brush as near as possible in size to the one I describe. The size of the brush is more important than the type. If you cannot get hold of a coarse brush, remember that rough-textured strokes can be created with a firm brush that has had its bristles very slightly twisted.

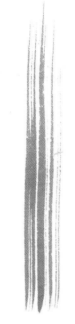

Fig. 17 Split-brush stroke

Fig. 18 Pushed stroke

THE PAPER

Beginners often find Chinese painting paper difficult to use but discover that what at first appear to be drawbacks can be exploited in ways which offer new and exciting artistic possibilities.

Most oriental painting papers are more absorbent than watercolour paper. Some are not sized at all, others are lightly or heavily sized. Not all papers absorb in the same way. Some simply soak up the paint where it is put; others allow the colour to run a little before it soaks in. Certain types of paper seem to encourage just one colour to run so that blue and yellow, for example, separate slightly if put on together. If you damp some *shuans* before painting on them, the result will be a faint blurring of your strokes. If you paint on others when they are damp, your strokes will lose their shape entirely. Curiously, on some papers, colour spreads less far if the paper is wet than if it is dry. Experiment with unfamiliar types of paper to discover their properties before embarking on a painting.

Mastering the absorbency

For the purposes of demonstration, I have used 19-in *shuan* of the kind sold in rolls of ten sheets. This is hand-made, unsized paper. It is cheap, very strong and versatile.

Fig. 19 shows a basic absorbency test. Fill your brush with grey ink and press the tip on to the paper. For **a**, lift the brush straight off again; for **b**, leave it resting on the paper until the ink has finished spreading. This demonstrates the need to work fast if you want clean, crisp strokes and shows that a gentler, slightly furry image can be created by working more slowly. Because of the paper's absorbency, if you want to taper a stroke, as in **Fig. 13**, you have to continue the movement off the paper into the air. If you leave the brush in contact with the paper, you create a bone stroke with a blunt end as in **Fig. 12**. This test also reveals something about the nature of this particular kind of paper: although the ink has spread in **b**, you can still clearly see where the brush was laid. This would not happen with some other papers and it shows that the absorbency of this particular paper is fairly easy to control.

Most oriental painting papers have another characteristic: whatever you put on the paper first stays on top. **Fig. 20** shows two bamboo leaf strokes; **a** was painted first and **b** laid over it but the second stroke has sunk behind the first. Even a stroke made with just water will show after you add ink or colour. For **Fig. 21** I made a circular patch on the paper with clean water, then covered the area with ink.

Fig. 19 Basic absorbency test

Fig. 19a Fig. 19b

Fig. 20 Overlapping strokes

Fig. 20b Fig. 20a

Fig. 21 Damped patch

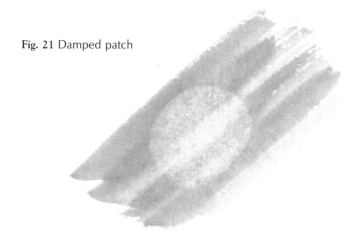

The damped patch shows clearly. However, this effect works only to a certain extent. Provided it has dried, you can cover a stroke with very black ink or with thick gouache colours.

Individual brush strokes show more clearly on oriental paper than on almost any other sort of painting surface. **Fig. 22** shows four strokes laid side by side with equal pressure, the brush loaded only once. You can clearly see the divisions between the strokes. On this paper the divisions show up darker; on some other kinds of paper the joining of two strokes is marked by a very thin white line. Because every stroke shows, it is important to make each one relevant and to use as few as possible. Each stroke must contribute to the spirit of the subject, and shapes can be made to look three-dimensional only if every brush stroke is deliberately placed and executed.

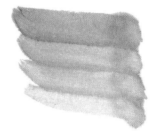

Fig. 22 Strokes laid side by side

To avoid a differentiation between strokes you have to work on damp paper, and a number of the effects in my paintings are achieved in this way. The kind of *shuan* that I have used here works very well damp; ink and colour stay where they are put unless I choose to blend them in.

Unless otherwise stated, the paintings in this book were done on the 19-in *shuan* I have used for these demonstrations. Where I have used other papers I have described their properties in relation to the particular painting.

Peddar's Way, Suffolk,
40 × 55 cm (15¾ × 21½ in)
I worked the trees in this painting on dry paper in the normal way. However, while the ink was still damp I blurred the upper branches by brushing over them with a wet hake brush. I used white Taiwanese cotton paper, enhancing the snowy effect with Chinese white.

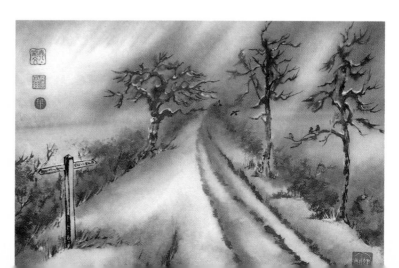

THE INK

The consistency and tone of your ink are very important and can make the difference between a lifeless, uninteresting painting and a lively, exciting one. Always begin by grinding your ink very black and very thick, and keep it like that on your ink stone. If you want to use ink that is still black but less thick and sticky, put some of the thick ink on to your palette and add a very little water. To make lighter tones use less ink rather than more water as this will prevent your ink from becoming too sloppy and will keep the tones fresh.

I have already described on page 25 how the heel of the brush acts as a reserve tank for moisture. This allows you to load your brush with more than one ink tone at a time. In **Fig. 23** stroke **a** is made across the brush, using the full length of the bristles. Load your brush with clean water, wipe off the excess liquid on the side of the water pot, then fill the top two thirds of the brush-head with grey ink. Again, wipe off the excess moisture before dipping just the tip of the brush into thick, black ink straight from the stone. Stroke **b** is also made across the brush, using the full length of the bristles. This time, load the brush fully with grey ink before tipping it with black as before. With another brush, apply thick black ink to the base of the bristles, working all the way round.

In **Fig. 24** stroke **a** is made along the bristles. Fill your brush with light grey ink and splay out the tip to give a straight end but not enough to split the bristles. Very gently, stroke the sides of the brush-head with ink from the stone. For stroke **b** load the brush as for **Fig. 23a** and paint a stroke similar to the ones in **Fig. 16**.

Fig. 24 Varying the stroke and the tones

Fig. 23 Loading different ink tones

Fig. 23a

Fig. 23b

Fig. 24a

Fig. 24b

COLOURS

In many of my landscape paintings I use comparatively little colour. However, I take a great deal of care with the colour that I do use, taking time to mix it to the tone and consistency I want. Except where I want opaque colour, I preserve the translucency of my paints by adding water, rather than white, to lighten shades. As with ink, you can make a paler tone by using less colour rather than by adding more water.

Essential colours are: burnt sienna; vermillion; sky blue; Chinese rattan yellow or Japanese cloeseed yellow; Chinese indigo or Japanese ultramarine; Chinese bright red or a Japanese red; Chinese green or Japanese light green. You will also need some gouache or poster white, and it is helpful also to have some Chinese or Japanese white as these are thinner than poster white. In nearly all cases these colours will provide the tones I have used in the paintings in this book, or a near equivalent. You may need to modify some of them: ultramarine is much brighter than indigo so tone it down with burnt sienna; brighten Japanese bloddy (*sic*) red by adding a little vermillion; add sky blue to Japanese light green to make it more like Chinese green. There are other differences too: rattan yellow is translucent, whereas cloeseed yellow seems to have a little white mixed with it; some Chinese sky blues are opaque, the translucent ones are very bright and need to be treated warily; Japanese sky blue, which I normally use, is translucent but less violent.

The only other colours that I use regularly are Japanese autumn brown, peony purple and squab red, and Chinese cinnabar. All these can be made by mixing other colours: blue and burnt sienna make dark brown; blue and red make purple; red, blue and gouache white make squab red; vermillion, red, burnt sienna and a touch of gouache white make cinnabar.

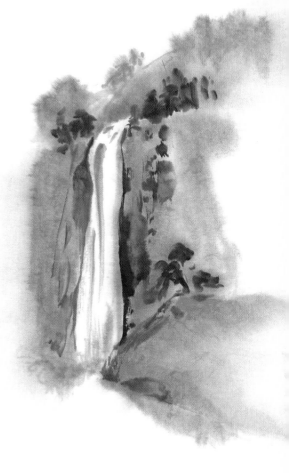

OTHER EFFECTS

Most of the more unusual techniques involve either changing the paper in some way before adding the paint, or applying the paint with something other than a brush, or both. You can damp or crumple the paper, or apply some sort of resist. My favourite tools for applying paint, apart from my brushes, are my sponges.

Wherever I have used an unusual technique in this book, it is described in detail in the context of the particular example.

ELEMENTS OF THE LANDSCAPE

山水之内容

Almost every scene is constructed from several elements –
mountains, a river, buildings, trees, a road and so on. In
this chapter, these elements are treated separately because
I believe that you need to know the general method for
painting trees, for example, before you try to achieve a
likeness to a particular tree. I avoid outlining trees, rocks
and hills because this makes them look two-dimensional.
Instead, I block them in with grey ink and use darker grey
and black for accent and emphasis. Darker accents can
be achieved either by tipping the brush as described on
page 32 or by adding them later while the grey is still wet.

In the following examples the whole process of painting
each element is described. However, in my paintings,
unless I am working directly in colour, I usually complete
the picture in shades of grey and black before I add
any colour.

TREES, BUSHES AND GRASSES

There are two main methods of painting trees. You can
build the tree up, using several strokes to give the trunk
shape and texture (see the willow and pine trees below)
or you can use just one or two strokes for the main trunk,
relying on the loading of the brush to give tonal variation
and texture (see **Figs. 29, 30** and **31**). Often, trees whose
trunks and main branches are built up with several strokes
have each side branch painted with a single stroke.

The Smoky Mountains, USA,
46 × 35 cm (18 × 13¾ in)
The mist over the Great Smoky
Mountains is qualitatively
different from the mist that sits in
the valleys and cloaks the tops of
hills in the Western Highlands of
Scotland and in the Haute Loire
and the Ardèche in France. It is
easy to see how the mountains
got their name for they appear
to be covered by a smoky haze.
The painting is on cotton paper.
I mixed indigo with the ink for
the distant range and sponged
the foreground foliage on to
the paper.

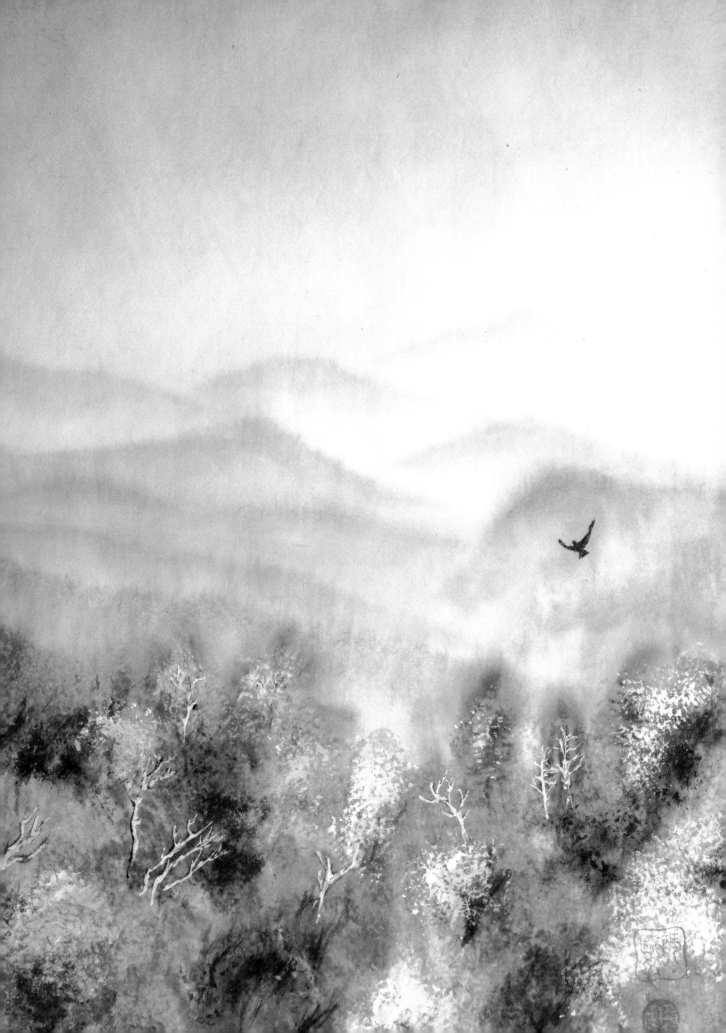

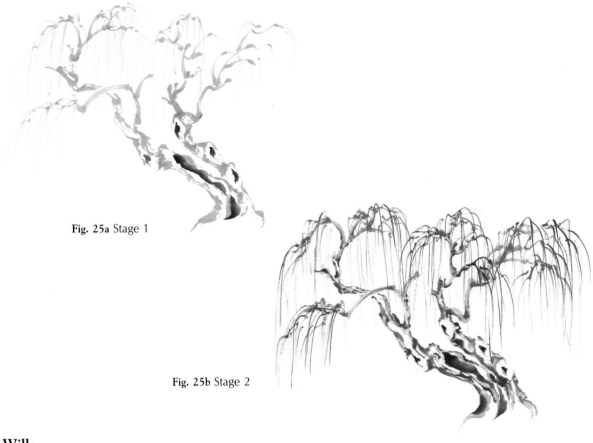

Fig. 25a Stage 1

Fig. 25b Stage 2

Willow

The tree in **Fig. 25** was done with a coarse, 3.5 × 1.5 cm
(1⅜ × ⅝ in) brush. I began **Stage 1** by putting in the four
small knot holes with thick, black ink, using a stroke
similar to the one described for **Fig. 16**. Then I filled the
brush about half-way down the bristles and pressed the
tip firmly on to the paper, turning it slightly and lifting
it so that the stroke tapered as the brush came away. For
the large split at the bottom of the left-hand trunk, the
brush was filled with dark grey ink and the top third of the
bristles redipped in thick black. Starting at the top of the
split, I placed this top third of the bristles on the paper
and pressed lightly, then pulled the brush downwards along
the split, with the head at an angle of about 45 degrees,
and tapered the stroke off the paper. Without reloading
the brush, I put in the indentation at the foot of the tree
and then laid the brush sideways on to the paper where I
wanted the tree to end, and pulled it upwards across the
bristles, lifting it to create a ragged, tapered edge.

The shape of the trunk was worked in grey, keeping the
brush fairly dry. The pressure and the angle of the brush-
head were varied and I worked fast, with vigorous strokes. I
put in the main branches, working across the bristles of the
tip of the brush, pausing and pressing down at the joints.

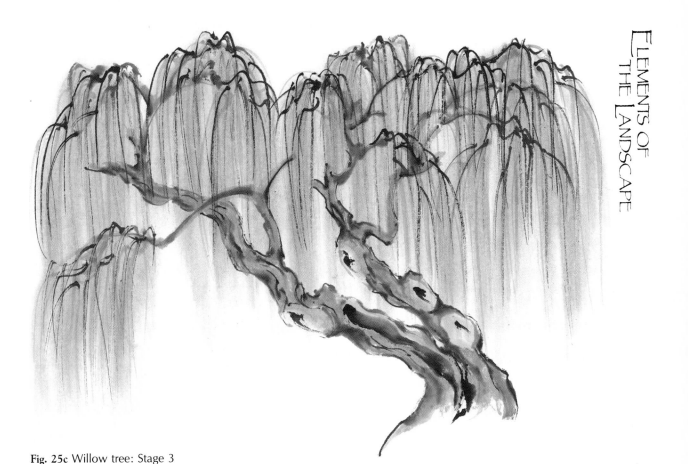

Fig. 25c Willow tree: Stage 3

The stroke is similar to the one shown in **Fig. 10d**. For the fronds I used sweeping, tapered strokes along the bristles of the brush tip, allowing the shapes of the clusters to develop naturally.

The black highlights were added to the trunk and branches (**Stage 2**) while the grey ink was still wet. I kept the brush very dry so that, although some of the strokes blurred when they met the wet grey, others stayed crisp. As before, I varied the pressure and angle of the brush-head as I worked. The black fronds and a few small connecting branches were then put in.

Finally, in **Stage 3**, the colour was added. For the trunk and branches I used a dilute mixture of sky blue and autumn brown, which I ran in with a 3 × 1 cm (1¼ × ½ in) soft brush. The whole trunk was covered, including the white areas, and the colour carried out along the branches.

When the ink had dried, I damped the paper evenly all over and made a mixture of sky blue, indigo and autumn brown for the fronds and filled the brush with this. I put in wide bands of colour with sweeping downward movements, pressing down with the whole brush-head and tapering the strokes off the paper below the bottom of the fronds.

Pine

I used a 3 × 1 cm (1¼ × ½ in) firm brush, known as a plum blossom brush, for the pine in **Fig. 26**. For **Stage 1** I put in the two knot holes in the same way as on the willow tree, **Fig. 25**. Then I painted the split at the base of the trunk with a stroke very like the bamboo leaf described for **Fig. 15**.

Next I filled the brush with dark grey ink, tipping it with black, to put in the undersides of the roots. The stroke used was very similar to that used for the split but, this time, I turned the brush-head as the pressure was increased, so that the grey portion of the bristles made contact with the paper and the stroke twisted.

The shape of the tree was established in grey by working up the trunk, creating the scaly effect with rough, uneven circles made across the bristles. There was no outline to work from so I needed a clear idea of the shape before I started. The side branches were put in with free, swinging strokes across the tip of the brush.

With the tip of the brush and very black ink I added emphasis and highlights (**Stage 2**), taking care not to outline, and varying the angle and pressure of the brush to increase the liveliness of the strokes.

Still with black ink, I added the pine needles (**Stage 3**), using the tip of the brush to make small, straight, tapered strokes in characteristic clumps. Some small connecting branches were also added in black ink.

Then I changed to a soft brush and ran some light grey ink down the right-hand side of the trunk. I also added a few grey needle clumps (**Stage 4**).

Lastly, I made a dilute mixture of autumn brown, burnt sienna and sky blue, and ran it over the trunk and branches (**Stage 5**). Before washing colour over the needles, I damped the paper evenly all over. With a dilute mixture of indigo, sky blue, rattan yellow and autumn brown I ran colour on just the needles, blending this outwards with a clean, damp wash brush.

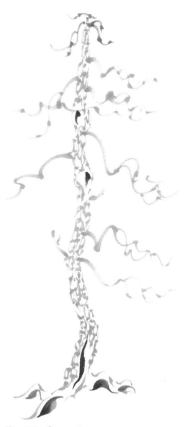

Fig. 26a Stage 1

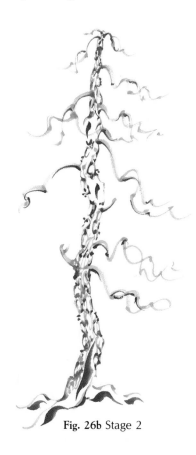

Fig. 26b Stage 2

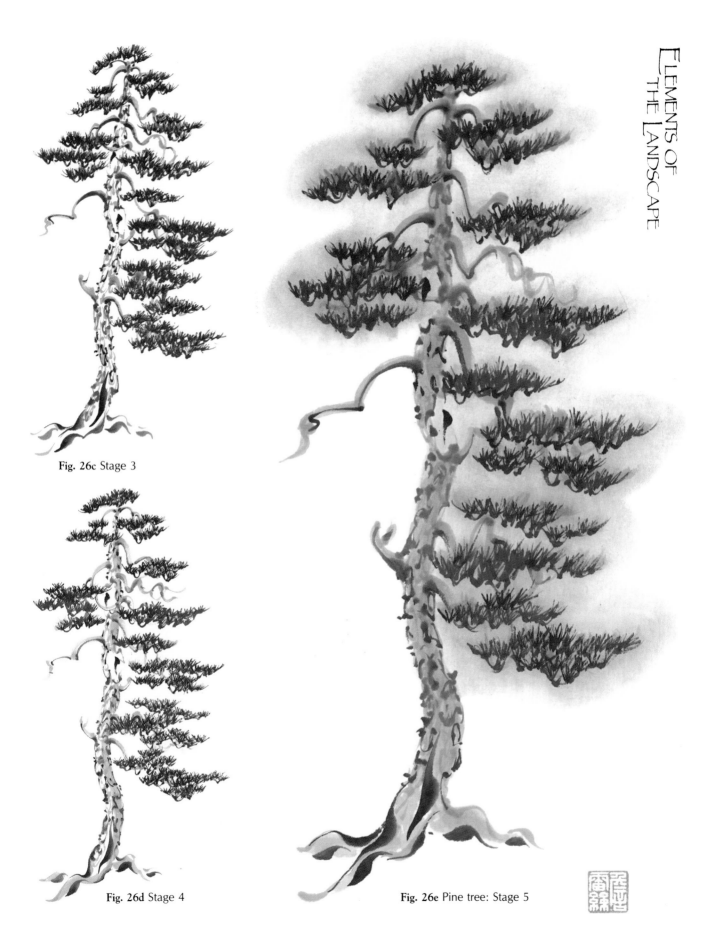

Fig. 26c Stage 3

Fig. 26d Stage 4

Fig. 26e Pine tree: Stage 5

Copper Beech

The copper beech tree (**Fig. 27**) was done with a semi-coarse 4 × 1.5 cm (½ × ⅝ in) brush. In **Stage 1** the main shape of the trunk was established with just two strokes. Working up from the base of the trunk, as the tree grows, and using the brush across its bristles with the tip outwards, I painted the left-hand side of the trunk, then continued the stroke out to form the left-hand, forked branch. Turning the brush round so that the tip formed the right-hand side of the trunk, I repeated the stroke, again taking it out to form a fork. The other main branches and some smaller ones were then added. I tipped the brush with black ink and put in the knot holes and some accents, and added some texture, skimming the paper lightly across the bristles, creating plenty of 'flying white'.

For the leaves in **Stage 2**, I used a small, open-textured, natural sponge, damped, squeezed out and filled with grey ink. The leaf clusters were applied with light dabs of the sponge. The darker leaves were added in the same way, using thick black ink picked up from the stone (**Stage 3**). I concentrated this darker foliage where I wanted shadow. While the sponge work was still damp, I added some more small side branches in black.

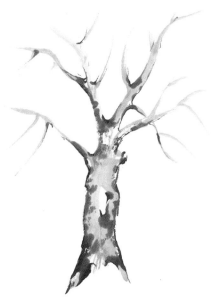

Fig. 27a Stage 1

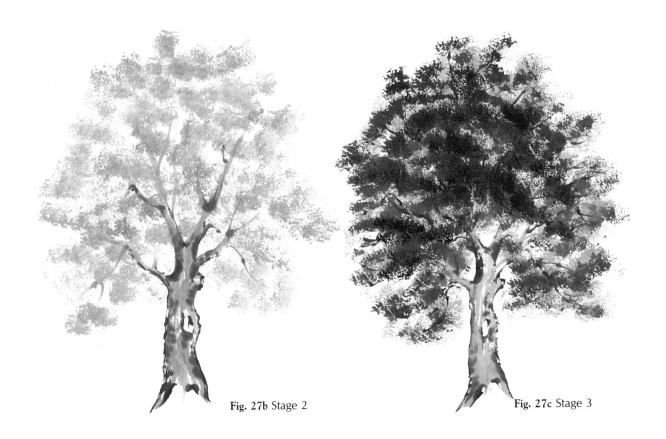

Fig. 27b Stage 2

Fig. 27c Stage 3

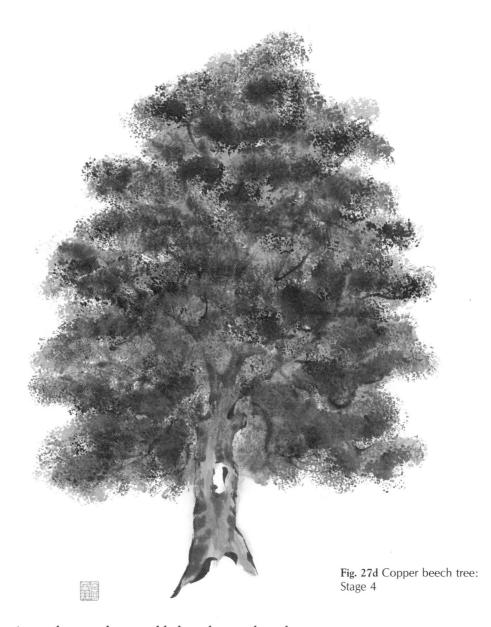

Fig. 27d Copper beech tree:
Stage 4

In **Stage 4**, a colour wash was added to the trunk and
branches, using a mixture of indigo, sky blue, autumn
brown and a touch of cloeseed yellow. I filled a 4 × 2 cm
(1½ × ¾ in) soft brush with the colour mixture and
pressed its full length sideways on to the trunk. I worked
slowly up the tree, moving first the heel of the brush
and then the tip without lifting it off the paper, pressing
constantly. I avoided the area around the knot hole,
washing over this and any areas where the colour flowed
outside the trunk with clean water. Then I ran some colour
over the larger branches.

When the trunk colour was dry, the same sponge, filled
with a dilute mixture of bloddy red, autumn brown and
burnt sienna, was dabbed lightly over the leaves. A thicker
version of the same colour mixture was then added to the
darker areas of foliage.

Birch

Essentially the same method was used for the birch tree in
Fig. 28. Using a plum blossom brush and clean water
only, I established the shape of the trunk and main
branches, and added black markings, which bled into the
wet area and created the texture and shape shown in **Stage 1**.
Some side branches were added in the normal way.

The leaves in grey ink were painted first and the black
ones added while these were still wet (**Stage 2**). To create
the leaf shapes, I dabbed the tip of the brush on to the
paper, lifting it cleanly off after each leaf. Because the
leaves hang downwards, I kept the tip of the brush
pointing upwards.

Once the tree had dried, **Stage 3** was completed with a
few leaves in neat Chinese green.

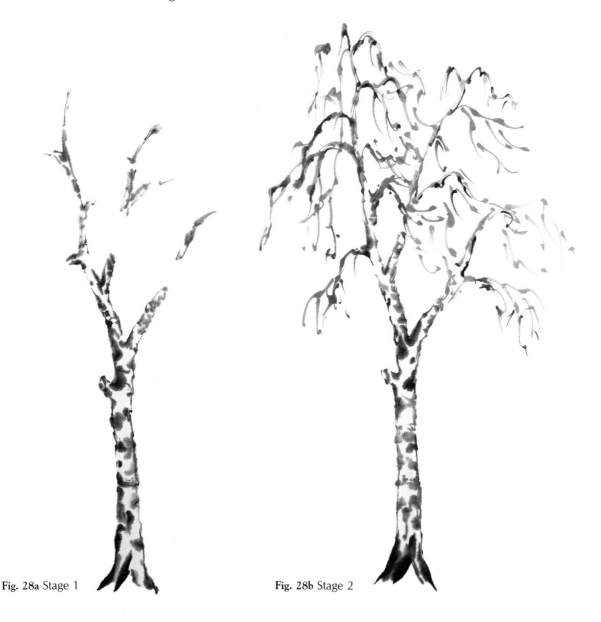

Fig. 28a Stage 1 Fig. 28b Stage 2

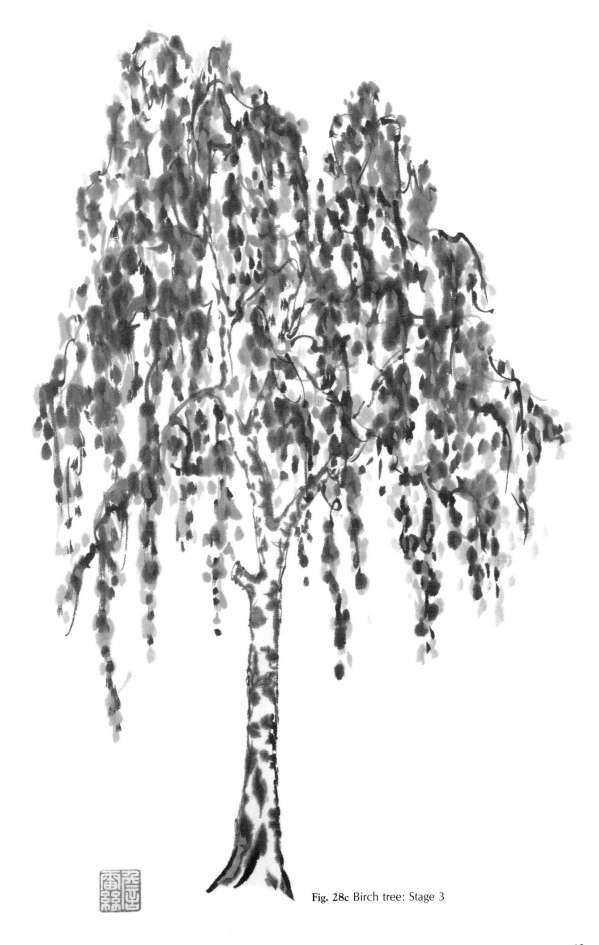

Fig. 28c Birch tree: Stage 3

Larch

Normally I paint things the way that they grow: beginning a tree at the foot and a branch where it joins the trunk. Occasionally, however, I start at the top when I want to paint the trunk in a single stroke and denser ink or colour is needed at the top. This also makes it easier to get the right shape for tall, thin trees, such as the larch in **Fig. 29**.

I filled a coarse, 4 × 1 cm (1½ × ½ in) brush with grey ink, then dipped the top half of the bristles into black ink. I placed the tip of the brush at the top of the trunk and moved it downwards, beginning the stroke along the bristles, gradually increasing the amount of brush-head in contact with the paper while, at the same time, altering the angle of the head so that it was about 45 degrees at the foot of the tree. This stroke formed the body of the trunk and the left-hand side of the tree base (**Stage 1**). Without redipping the brush, I made a second small stroke to form the right-hand side of the base. The side branches were added in black ink, with some splodges to represent lichen or moss.

For the leaves I used a small, 3 × 1.5 cm (1¼ × ⅝ in) coarse brush because its bristles would splay out to create the effect of clumps of needles. I filled the brush with thick black ink and dabbed it on to the paper with the tip towards the branch (**Stage 2**). I put in clumps where I wanted extra side stems, adding these where necessary, plus a few black splodges to represent flowers.

A mixture of autumn brown and indigo was run over the trunk (**Stage 3**). Before this dried, the paper was damped evenly all over so that the trunk colour bled slightly, creating a light wash behind the tree. For the needles I used cloeseed yellow, toned down with a little indigo and some burnt sienna, and added the colour as for the pine.

With a thick mixture of gouache white, gouache yellow and Japanese light green, I added more needles, using the same method as before and keeping the brush as dry as possible.

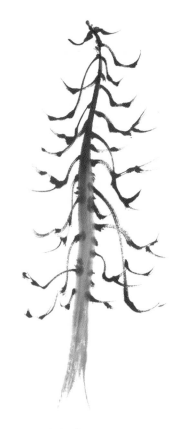

Fig. 29a Stage 1

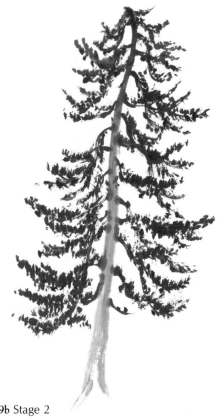

Fig. 29b Stage 2

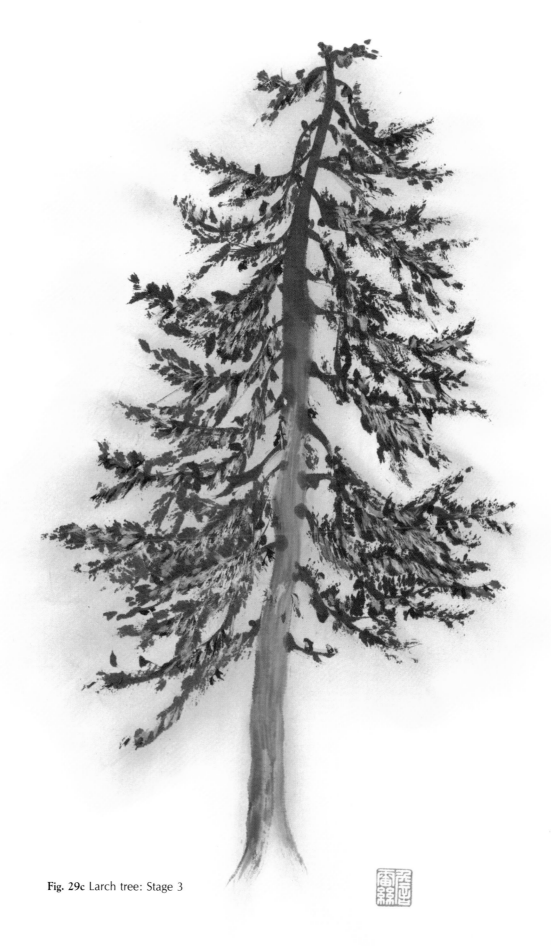

Fig. 29c Larch tree: Stage 3

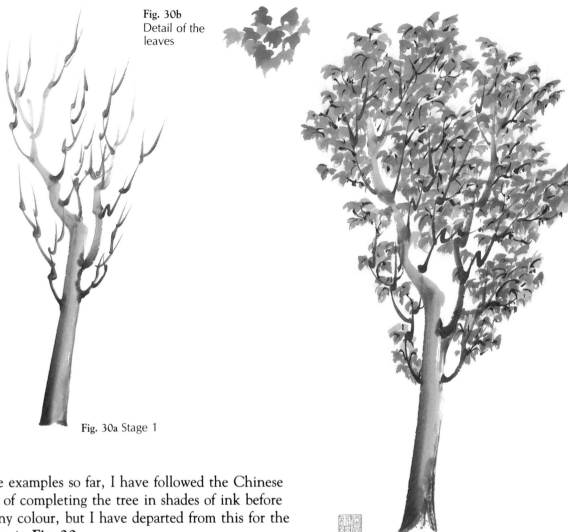

Fig. 30b
Detail of the leaves

Fig. 30a Stage 1

Fig. 30c Maple tree: Stage 2

Maple

In all the examples so far, I have followed the Chinese tradition of completing the tree in shades of ink before adding any colour, but I have departed from this for the maple tree in **Fig. 30**.

I filled the top two thirds of a 4 × 2 cm (1½ × ¾ in) firm brush with grey ink and tipped it with black. Beginning at the foot of the tree and working across the bristles, I moved the brush briskly up the trunk and out along the main bough (**Stage 1**). Retipping the brush with black, I then added the side branches and a few dark accents, and gently retouched the right-hand side of the trunk, working the tip across the bristles to emphasize the edge of the tree.

In **Stage 2** I added the leaves. Using a plum blossom brush and thick colour, I built up each leaf with a series of strokes similar to the one in **Fig. 14c**, beginning with the centre segment. The other segments were added in the same way but the angle of the brush-head was altered (see **Fig. 16**). The slightly ragged edges of the leaves were achieved by keeping the brush dry. Using the tip of the brush and black ink, I added a few veins to the leaves and some small V-shaped splodges to represent seeds.

Palm

As well as leaves, you may want to paint tree trunks
directly in colour (see **Fig. 31**). For the palm tree I filled a
1 cm (½ in) hake brush with a mixture of autumn brown,
rattan yellow, indigo and Japanese light green. I painted
the trunk in a single stroke, working along the bristles,
alternately raising and pressing the brush while keeping
it in contact with the paper. When I reached the top, I
pulled the stroke out across the tip of the bristles to form
the beginning of the fan of leaves. I then changed to a
4 × 1 cm (1½ × ½ in) coarse brush and added the leaves
in the same colour, putting in the spine with a tapered
stroke along the bristles and adding the fronds with tapered
strokes across the brush-head, working away from the spine
(**Stage 1**). The black markings on the trunk and the leaves
were added with the tip of the same brush. Lastly I put in
the coconuts with a mixture of autumn brown and indigo,
highlighting them with black ink (**Stage 2**).

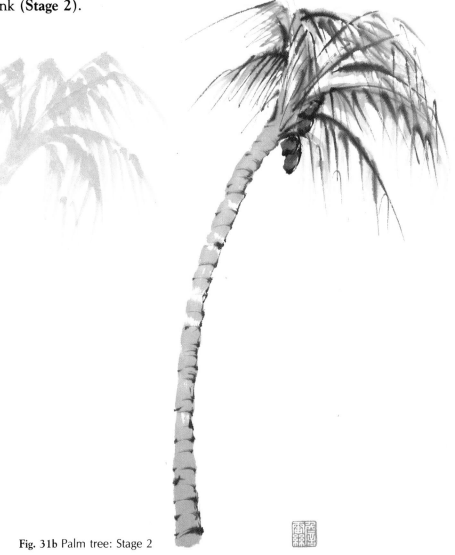

Fig. 31a Stage 1 **Fig. 31b** Palm tree: Stage 2

47

Other trees

Sometimes a particular variety of tree gives a scene its distinctive character: only a willow would convey the spirit of the scene in **Fig. 1**; rows of poplars are typical of East Anglia, and cypress trees seem to belong in hot, sunny scenes. However, when you think about a scene you may remember only a general impression of greenery, or very tall trees, or short scrub. When you paint a scene try to be faithful to your impressions of it and do not worry too much about botanical accuracy.

Fig. 32 Trunks and branches

Fig. 32a Fig. 32b Fig. 32c

For the tree in **Fig. 32a** I used a dry 4 × 1 cm (1½ × ½ in) coarse brush, filled with dark grey ink and tipped with black. Starting at the roots, I moved the brush lightly upwards, working across the bristles and just skimming the paper, to make the trunk. The brush was kept dry and used very lightly to create plenty of texture. A few accents and some lichen were added in the usual way.

For **b** I used a plum blossom brush filled with a dilute mixture of autumn brown and rattan yellow, putting in the roots first as before and then working the brush across the bristles up the trunk. Some black accents were added and finally some patches of light green.

For **c** I filled the same brush with black ink and began with the left-hand root, using the brush along the bristles. Without lifting the brush or turning it, I made a sweeping stroke, across the brush-head, up the trunk. The other root, branches and lichen were then added.

Fig. 32e

Fig. 32d

Fig. 32f

Fig. 32d, for which I used the same plum blossom brush, shows in detail how branches are joined. I pressed down slightly with the brush to thicken the stroke where one branch joined another, or where a branch changed direction, but tapered the strokes off the paper at the ends of branches.

The branch in **e** was painted directly in colour, with a little black and light green highlighting. To convey an impression of branches being blown by wind (**f**), the brush was kept very dry and the strokes almost flung on to the paper.

Fig. 33 shows alternative ways of depicting foliage, using a plum blossom brush. You can achieve variations on these leaf patterns with a softer or coarser brush or by varying the wetness of your brush; by altering the pressure or the amount of brush-head you use; and by changing the speed of your strokes. You can do leaves first in black and then grey; or grey first and then black, which will make them blur more; or try a split-brush technique. Experiment to find the effect you want.

In **Fig. 33a** the leaves were drawn untidily in black ink with the tip of the brush. For **b**, the brush-head was filled with light grey ink and tipped with black. The brush was repeatedly laid lengthways on to the paper, pressed down and lifted off cleanly after each application. In **c** the brush was laid vertically.

In **d** the top third of the brush-head was filled with light ink and the same method was used as for the maple leaves, page 46, although each leaf consisted of only three parts.

For **e** the brush was filled with black ink, repeatedly stabbed vertically on to the paper and lifted cleanly. This was then repeated with grey ink.

Fig. 33 Leaf patterns

Fig. 33a

Fig. 33b

Fig. 33c

Fig. 33d

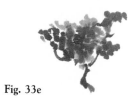

Fig. 33e

Distant trees

Distant trees appear more solid and their colours merge together; you see fewer details, and paler colours. **Fig. 34** shows a selection of distant trees painted with a plum blossom brush.

For **Figs. 34a** and **b** the foliage was applied with a small natural sponge. I used pale grey ink to establish the shapes of the trees and added some slightly darker ink. Lastly I added the trunk with the brush. In **c** and **d** the trunks were done before the leaves.

You can increase the impression of distance and make trees look as if they are shrouded with mist if you damp the paper first (**e**). **Fig. 34f** shows a clump of distant trees. The trunks were all put in first, then the brush was filled with grey and its full length laid on the paper several times to make the foliage.

I normally add a light colour wash to distant trees in the same way as for the pine and larch foliage (see pages 38 and 44).

Fig. 34 Distant trees

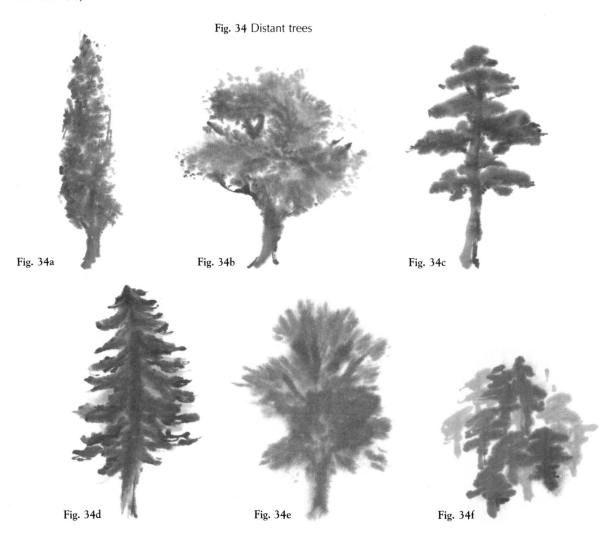

Fig. 34a

Fig. 34b

Fig. 34c

Fig. 34d

Fig. 34e

Fig. 34f

Fig. 35 Bushes

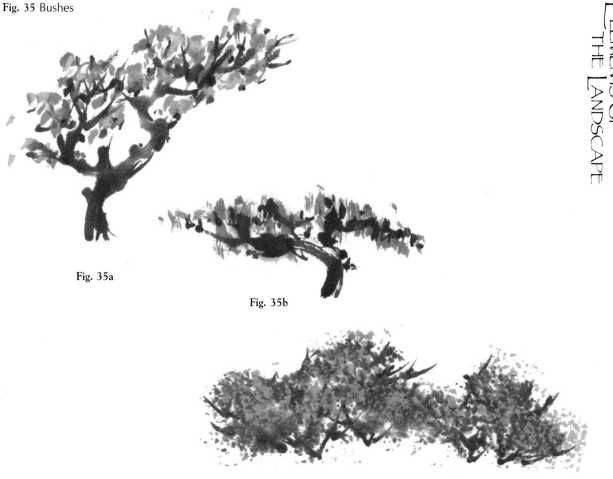

Fig. 35a

Fig. 35b

Fig. 35c

Bushes

You can use the same methods to depict bushes as to paint
trees (see **Fig. 35**). The stem and branches of the fruit
bush (**a**) were done with a plum blossom brush. Instead of
putting on leaves, splodges of colour were added for the
blossom with the tip of the brush, first in bloddy red mixed
with a very little white, then with more white added to
the colour.

Fig. 35b shows the sort of bush that I sometimes depict
growing from a crevice in a rock. I used a 4 × 1 cm
(1½ × ½ in) coarse brush to paint the stem and branches
first; then, keeping the brush so dry that the end split of its
own accord, I added the leaves in vermillion, stroking the
paper lightly across the bristles.

For the clump of bushes (**c**), I used a small damp natural
sponge and applied the grey and black ink together. This
was done by filling the sponge with grey ink, squeezing out
any excess, then picking up a little thick black ink. The
stems were added in black, with the tip of a brush. Finally,
some light green was sponged on to the foliage.

Fig. 37 Short grass

Fig. 36 Long grass

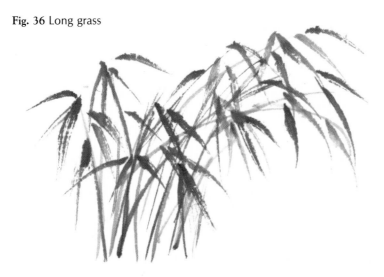

Grasses

Tall grass in the foreground of a painting can sometimes perform a compositional role similar to that of a small tree or bush. Also, grass is frequently included in paintings at the foot of trees or close to bushes.

The stalks of the long grass in **Fig. 36** were done with the tip of a 3 × 0.5 cm (1¼ × ³⁄₁₆ in) coarse brush, worked along the bristles. The leaves are a thinner, elongated version of the bamboo leaf in **Fig. 15**. However, I lowered only a third of the brush-head on to the paper before lifting it, and made the stroke longer before tapering it off.

For the short grass, **Fig. 37**, I used the same coarse brush and, keeping it as dry as possible, filled it with black ink. I dabbed the full length of the head horizontally on to the paper several times, tapering it slightly upwards and off. The bristles were then splayed out and turned to do the slightly longer grass with split, tapered strokes along the brush-head. Some lighter grass was added with grey ink.

For grass, as for leaves, it is worth experimenting to find the effect you want. Use different kinds of brushes, dry and wet; splay the bristles of soft and firm brushes; vary slow strokes with fast ones; add dark ink to light or work directly in colour.

ROCKS, BOULDERS AND CLIFFS

As well as striving for a three-dimensional effect when painting rocks, it is essential to achieve a sense of weight and durability. Unlikely as it seems, it is helpful to think about the heaviness of a rock when you are painting it, and to try to feel its mass.

You can build a rock gradually in shades of grey and black or you can try to convey shape and shading with all-in-one strokes (see **Fig. 41**). I seldom begin a rock directly in colour but I sometimes add thick colour, as I did for **Fig. 38**. More often I use gentler colour washes, although I sometimes enhance these with some thicker tones (see **Figs. 39** and **40**).

The boulder in **Fig. 38** was done with a plum blossom brush, filled with grey ink. I began by establishing the shape and some texture, using tapered strokes across the bristles (**Stage 1**).

Keeping the brush very dry, I refilled it with thick black ink and added the darker texture, across the bristles (**Stage 2**). A little detail was put in with the split tip of the brush, and some splodges of black as lichen.

For **Stage 3**, the brush was filled with a thick mixture of autumn brown, vermillion, rattan yellow and indigo, and pressed down on to the paper. Without lifting the brush-head, unless it was to refill it, and pressing constantly, first the tip and then the heel were moved over the rock until it was covered. Areas where the colour bled slightly outside the rock were washed over with clean water to avoid a hard edge. More autumn brown and indigo were added to the colour for the shadier parts of the boulder. Lastly I added splodges of Chinese green.

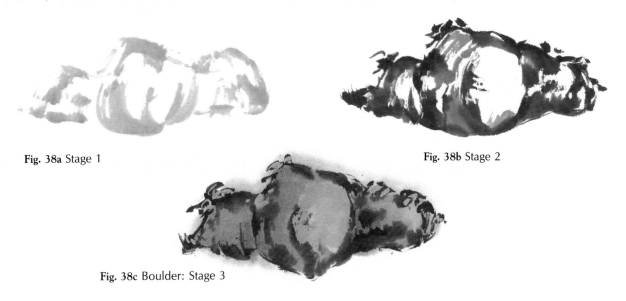

Fig. 38a Stage 1

Fig. 38b Stage 2

Fig. 38c Boulder: Stage 3

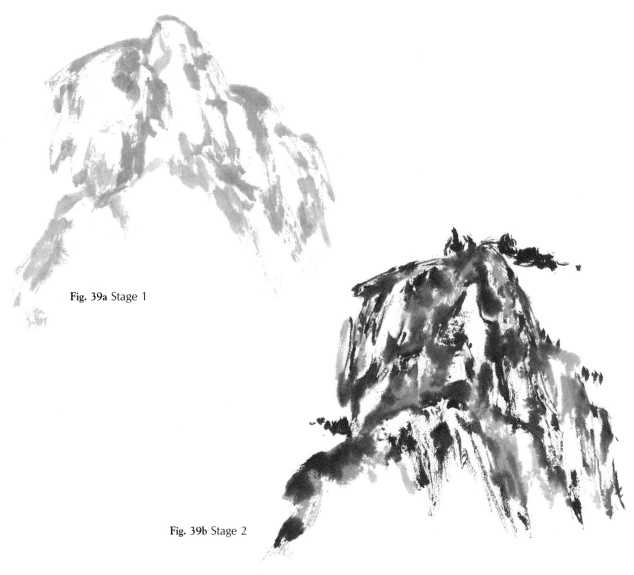

Fig. 39a Stage 1

Fig. 39b Stage 2

I used a 4 × 1 cm (1½ × ½ in) coarse brush for **Fig. 39** to establish the shape and some texture in grey ink, working across the bristles and keeping the brush fairly dry (**Stage 1**).

The black detail and texture were added immediately so that they ran into the grey in places (**Stage 2**). With the split tip of the brush and black ink I put in the undergrowth, using a press-and-lift stroke similar to that used for larch needles, **Fig. 29**.

Once the ink had dried, I damped the paper evenly all over, then, using a large soft brush, added some dark grey to the shaded areas of rock (**Stage 3**). With the paper still wet, I blended a mixture of indigo and autumn brown over the areas of undergrowth. The basic rock colour was a mixture of autumn brown and burnt sienna with a touch of rattan yellow, applied only to the darker areas of the rock and blended to give the lighter areas a faint tint.

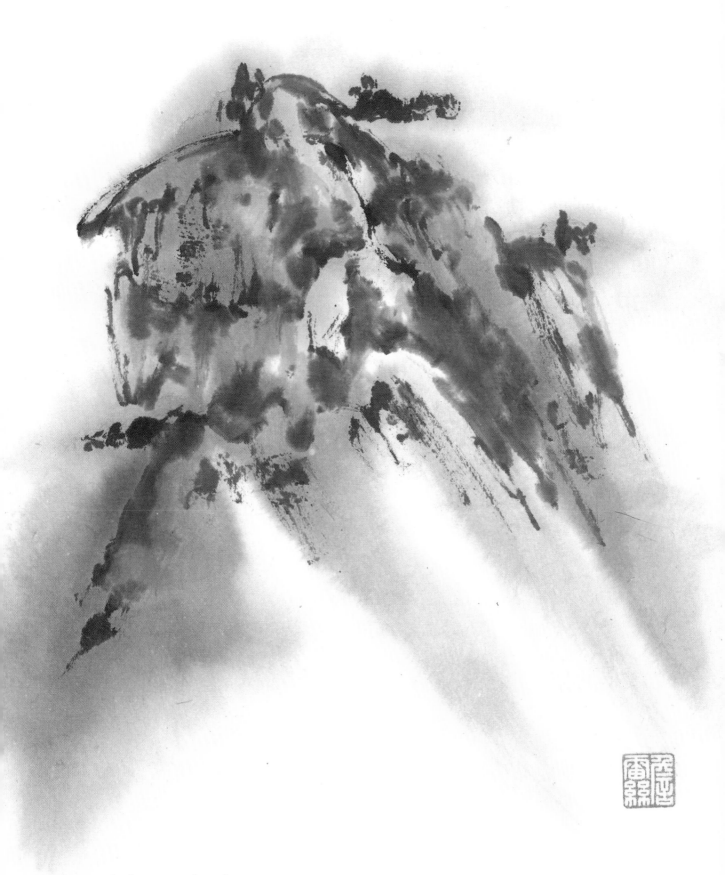

Fig. 39c Rocky outcrop: Stage 3

The same method was used for **Fig. 40**. **Stage 1** shows what it should look like after the ink wash has been applied. When applying ink shading, the brush should be filled with clean water, then only the top half of the bristles dipped into the ink. The whole brush-head should be pressed on to the paper with the tip towards the darkest area. The ink will run into the water from the heel of the brush, creating a subtle tonal gradation. The effect can be completed by blending with a clean hake brush.

After applying the basic colour wash in **Stage 2**, I used a 3 × 1 cm (1¼ × ½ in) soft brush to add some thick Chinese green in a few places, gently blending it into the surrounding rock.

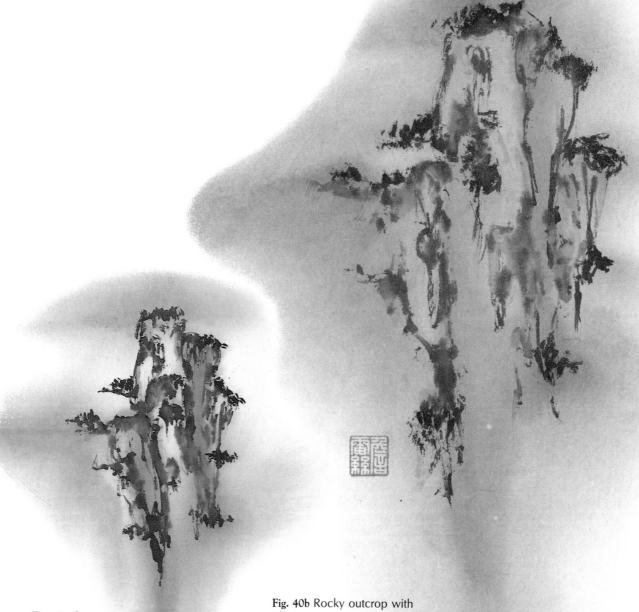

Fig. 40a Stage 1

Fig. 40b Rocky outcrop with Chinese green: Stage 2

To paint the cliff in **Fig. 41**, I established the shape, texture and shading all at the same time, using a 4 × 1.5 cm (1½ × ⅝ in) semi-coarse brush filled with grey ink and tipped with thick black. The full length of the brush-head was laid horizontally on to the paper at the base of the cliff, pressed down, and then moved upwards across the bristles. This stroke was repeated four more times, taking care to keep the base of the cliff level. Next, filling the tip of the brush with black and splaying it out, I used rough dabs along the bristles with the brush vertical to put in a suggestion of undergrowth at the cliff top.

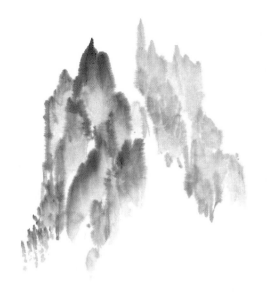

For the reflection, the brush was filled with a lighter shade of grey and tipped with dark grey. The five original strokes were mirrored, beginning at the base of the cliff and working downwards across the bristles, but using less pressure than before and tapering the strokes off the paper.

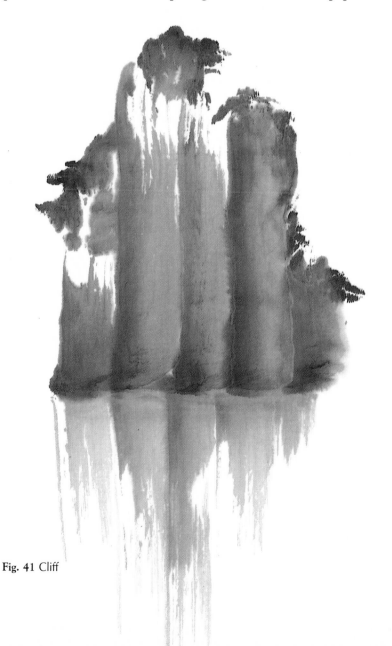

Fig. 41 Cliff

Fig. 42 Mountains

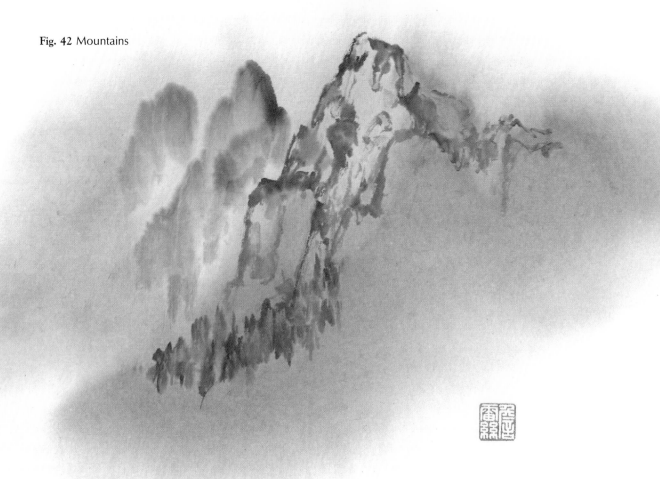

MOUNTAINS AND HILLS

Distant mountains and hills, or a section of them in the foreground of a painting, can consist of rocks, trees or grass or a combination of these, so it is important to be able to convey these differences in your painting.

I began the mountains in **Fig. 42** by establishing the shape and texture of the closer peak as for **Figs. 39** and **40**, using a 4 × 1 cm (1½ × ½ in) coarse brush. An impression of distance was created by beginning with light grey ink and using dark grey, rather than black, to enhance the detail and texture. Some distant trees were added with strokes similar to the ones used for the leaves in **Fig. 33c**.

For the distant peak, the brush, filled with light grey and tipped with darker ink, was laid full length vertically on to the paper, pressed down firmly and lifted cleanly. This stroke was repeated several times. As in **Fig. 41**, the paper clearly shows the edges of each stroke, and I exploited this idiosyncrasy to give the mountain texture and shape.

When the ink was dry, the paper was damped and some ink shadow blended on to the nearer peak. The distant

peaks were extended slightly by adding a grey ink wash to the base of the previous strokes and blending it downwards.

While the paper was still damp, I added some colour, varying the tones of the wash slightly and using a greener tint over areas of vegetation.

For the hill in **Fig. 43** I used a 5 × 1.5 cm (2 × ⅝ in) semi-coarse brush, filled with grey ink. This was laid full length vertically on the paper with the tip pointing upwards. I then rolled the brush, raising and lowering it slightly but keeping contact with the paper, to form the basic shape of the mountain.

Without rinsing the brush, I picked up some black ink with the top third of the bristles. Still keeping the brush vertical with its tip uppermost, I alternately pressed it on to the paper and lifted it almost off, while moving it over the tree-covered areas. On this type of hill you could add a light colour wash over the whole area, concentrating darker tones of green where there are trees.

Fig. 43 Tree-covered hill

When I am painting very distant mountains I usually work on damp paper. This gives the effect of a slight haze shrouding them and makes it easier to blend them into areas of mist.

For the example in **Fig. 44** I worked on evenly damped paper with a 3 × 1 cm (1¼ × ½ in) coarse brush, using the techniques described for **Figs. 39**, **40** and **42**. Very pale ink, combined with the blurring caused by the damp paper, gave the impression of distance.

The distant tree-covered hills in **Fig. 45a** were painted with a 4 × 2 cm (1½ × ¾ in) firm brush. This was filled with water, the top three-quarters of the head dipped into light grey ink and the tip into slightly darker ink. The brush was laid vertically on the paper, as for **Fig. 43**, and

Fig. 44 Distant rocky mountains

rolled over the hills in similar fashion. As with the rock shading, the water in the heel of the brush caused the ink to fade gradually into the paper at the base of the hills. Retipping the brush with the darker ink, I dabbed a little more texture on to the slopes.

For the grass-covered hills in **b** I used the same brush and a similar combination of water and ink. I rolled the brush as before but this time kept the pressure even, without lifting and lowering.

All the examples in **Figs. 44** and **45** were given a light colour wash while the paper was damp. In each case I kept the tones very dilute since distance tends to drain objects of colour. It also makes things look more blue and I took this into account when making up the wash colours.

Fig. 45 Distant hills

Fig. 45a

Fig. 45b

BUILDINGS

Since the paintings in this book are of Western scenes, I have provided examples of Western architecture. Buildings in traditional Chinese paintings were often given a firm outline and no shadow. This tended to make them look two-dimensional. It is possible that this was done deliberately to emphasize a contrast between the beauty of natural phenomena and the insignificance of man-made structures. My Western upbringing and way of seeing things leads me to want to depict buildings as three-dimensional. Therefore, I do use shadow and try to avoid too many definite outlines. Traditional Chinese landscape painters also frequently depicted buildings seen from above, but trees and people beside the buildings seen from ground level.

For the French farmhouse in **Fig. 46** I used a small 2 × 1 cm (¾ × ½ in) firm brush, known as an orchid brush, to establish the shape of the building (**Stage 1**), varying the angle of the brush-head and the wetness of the brush to put in shading and texture simultaneously. The roof tiles were drawn roughly with the tip of the brush and texture added to the ground in front of the house by keeping the brush very dry and making some light strokes, across the bristles.

I added black ink immediately so that it blended with the still-damp grey in places (**Stage 2**). Taking care not to outline the building, I added detail and texture, enhanced the shadows, and put in more texture on the ground.

Once the ink had dried, colour was added for **Stage 3**. Using a 3 × 1 cm (1¼ × ½ in) soft brush, I ran a dilute mixture of burnt sienna, autumn brown and rattan yellow over the walls, blending in a little more autumn brown in places. Some bloddy red was added for the roof and the doors were painted with burnt sienna and autumn brown. Grey ink, mixed with indigo and autumn brown, was used for the window openings and under the arch. The grass colour is a mixture of indigo and rattan yellow, toned down with a little burnt sienna.

The general method described above can be used for any style of building and it is the one I use in my paintings, although I do sometimes vary it slightly.

Fig. 46a Stage 1

Fig. 46b Stage 2

Fig. 46c French farmhouse: Stage 3

Fig. 47 St Peter's Church, Cambridge

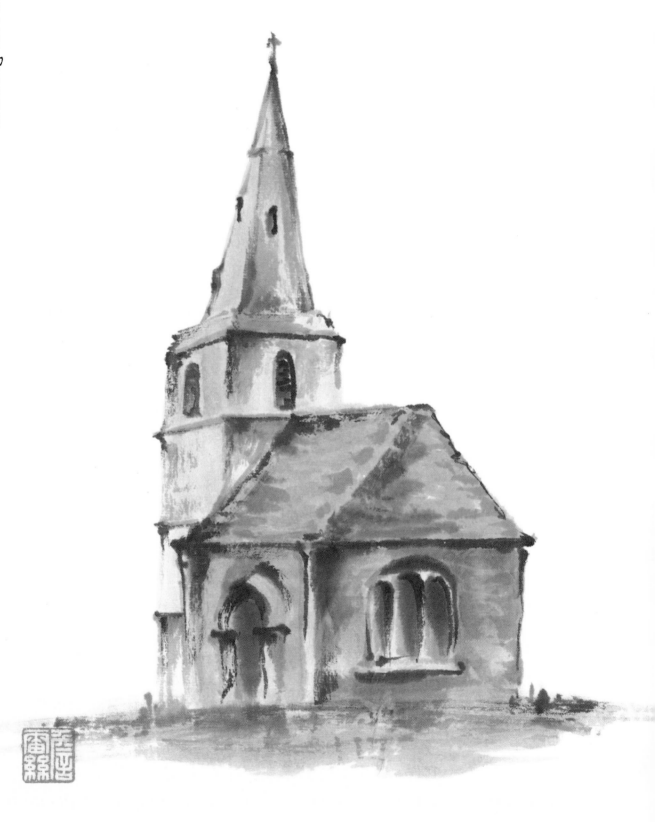

The church in **Fig. 47** was done in the same way as the
farmhouse, the roof coloured with burnt sienna and autumn
brown, mixed with a little bloddy red. Cloeseed yellow and
Chinese white were used for the lighter roof patches, the
window surrounds, and the corners of the walls. The walls
themselves were done with dilute autumn brown and the
lighter patches with pale yellow. For the tower, I diluted
the roof colour, toned it down with more autumn brown,
and added a tiny bit of sky blue. Because the colour was
so dilute, it bled outside the tower. I washed over these
areas with a clean brush because, although I did not mind a
gentle colour bleed, I did not want it to have a harsh edge.
Again, I added some lighter patches, this time using some
of the tower colour mixed with a little white.

The same technique was used for the bridge in **Fig. 48**.
A mixture of burnt sienna, indigo and cloeseed yellow was
applied and, once this had dried, I damped the paper evenly
all over before adding the reflection first in light ink and
then in a more dilute version of the colour.

Fig. 48 Clare Bridge, Cambridge

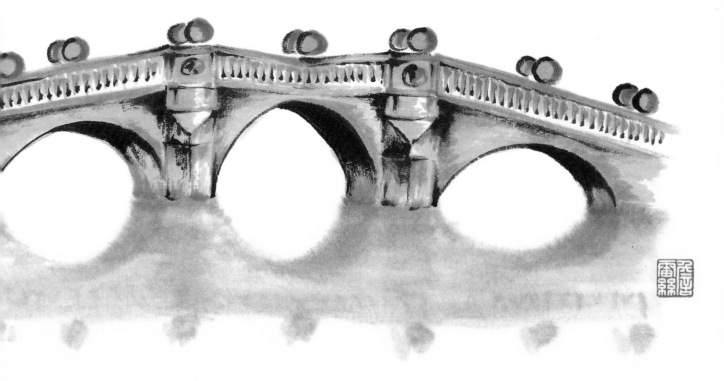

Fig. 49 Dolbadan Castle, Wales

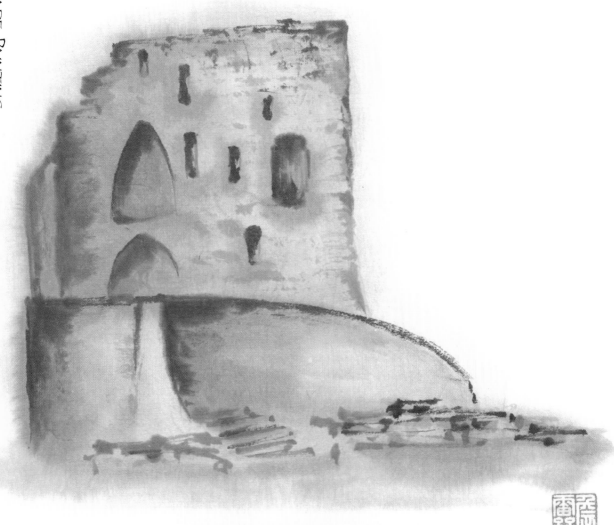

Using a 4 × 1 cm (1½ × ½ in) coarse brush, I
began the castle in **Fig. 49** by establishing the shape
and texture of the walls and the shadow. Once this had
dried, the paper was damped and some extra ink shading
added. With the paper still damp, I blended a mixture of
sky blue, indigo and autumn brown over the castle, and
then used Japanese light green mixed with a little gouache
white to highlight a few areas, blending it gently into the
surrounding colour.

As with trees and mountains, you can make buildings
look further away by painting them smaller, giving them
less detail and more uniform colour, and making them
paler in tone.

The skyscraper in **Fig. 50** was painted with an orchid
brush. In this case I did use a little black as well as grey,
but kept the detail to a minimum. Some dilute Chinese
white was brushed over the whole building, and one
or two places were highlighted by blending in slightly
thicker white.

The castle in **Fig. 51** was done entirely on damp paper.
I used a small, close-textured, natural sponge for the creeper
on the walls and a plum blossom brush for everything else.
The colour wash is a mixture of dilute Chinese white,
cloeseed yellow, burnt sienna and autumn brown for the
walls, and yellow and indigo for the creeper.

The windmill in **Fig. 52** was blocked in with a plum
blossom brush. I damped the paper before running autumn
brown over the main building and Chinese white over the
roof. The sails were redrawn in white and allowed to blur
on the damp paper.

Fig. 52 Windmill

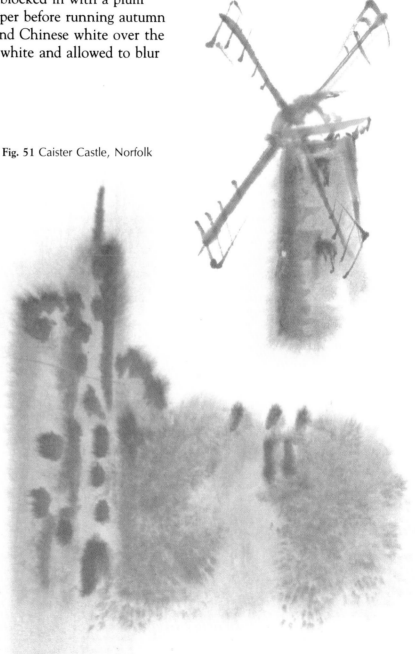

Fig. 51 Caister Castle, Norfolk

Fig. 50 Skyscraper

MOBILE OBJECTS

Even though an object may be a temporary phenomenon in a scene, it may still be an integral element in conveying the spirit of a painting: boats in the foreground of a harbour, horses and riders on a racecourse, for example. Other transitory subjects may be added by a painter for compositional reasons, or to add a note of animation: a distant skein of geese or a single eagle, for example. Their role is to enhance the spirit of the scene, not to create it. The following methods can equally well be applied to painting a variety of other subjects, such as cars and trains, or cows and sheep!

Vehicles

There are two main methods of painting any type of vehicle: you can either work first in grey, adding emphasis with black and putting on a colour wash, or you can work directly in colour and establish the shape with a single brush stroke.

Fig. 53 Boat

A plum blossom brush was used for the boat in **Fig. 53** to established the shape, texture, and shading in grey ink. Before this dried, I added more detail and texture with black ink and put in the mast as a single stroke in grey, touching up the top and one side with black, using the tip of the brush. When the ink was dry I ran a mixture of rattan yellow and burnt sienna over the hull, Chinese white over the cabin, and autumn brown over the mast.

For the boat in **Fig. 54** I filled a bamboo brush with a mixture of burnt sienna and autumn brown, tipping it with black ink, and tapered it down on to the paper, along its bristles, so that the tip formed the prow. I pulled the brush along to form the side of the boat, turning the brush-head until it was at right-angles and the lighter brown in the heel came at the bottom of the hull. The stern of the boat was touched up with a second stroke. The brush was refilled and retipped to paint the panel at the stern with a single stroke, across the bristles, working from left to right. The seats were done with tapered strokes across the bristles. An extra stroke reinforced the prow. Once the colour had dried, a dilute mixture of burnt sienna and autumn brown was used for the other side of the hull.

Fig. 54 Freestyle boat

I used an orchid brush for the bicycle in **Fig. 55**, establishing the shape and shading in grey before adding detail in black. Burnt sienna was used for the rusty areas, and indigo and autumn brown for the rest of the frame, with a touch of bloddy red on the saddle.

Fig. 55 Bicycle

People and animals

Traditional Chinese landscape paintings frequently contain one or more figures. These are usually engaged in some kind of intellectual or spiritual pursuit. Occasionally they are shown walking, or sitting in boats, perhaps fishing, but, except in the very long story-telling scrolls, they are seldom doing anything involving much physical exertion.

Like buildings, people in traditional paintings are often simply drawn with little or no shadow. They are frequently disproportionately small compared with surrounding trees and rocks, perhaps because the artist wanted to emphasize man's insignificance in the world. Figures in the foreground may be shown smaller than those further away. Possibly, painters did this when depicting real people, to reflect the relative status of their subjects.

Animals in traditional Chinese paintings are less likely than people to be outlined, but they too are not usually shown doing anything more energetic than walking.

Occasionally I include people and animals in my paintings but I depart from Chinese tradition in two ways: I try to make them look as three-dimensional as possible; and in the case of people, at least, I often show them engaged in some kind of physical activity, such as rowing or riding. I use as few strokes as possible to portray a person or an animal, trying to use each stroke to contribute to an impression of motion. To be able to capture a sense of movement on paper, you should observe people and animals carefully and understand how they move.

Using an orchid brush, I began the horse and rider in **Fig. 56** by putting in the shape of the horse and blocking in the rider with grey ink. A few touches of black were added for detail on both and colour run over the ink in the usual way.

I used the same orchid brush for **Fig. 57**. The punt was done by the method used for the boat in **Fig. 53**. I blocked in the shape of the girl, added a few details in black, then put on the colour.

Fig. 56 Horse and rider

Fig. 57 Girl in a punt

Birds

I often use birds to add a point of detail and an element of movement to my pictures. Sometimes I use a lone, circling bird to convey a feeling of space. **Figs. 58** to **62** show a selection of the birds likely to feature in landscape paintings. I use as few strokes as possible and keep them simple to convey an impression of a bird that is simultaneously an integral part of the scene and a separate entity in its own right. I used an orchid brush for all the examples below.

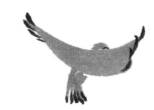

Fig. 58 shows an eagle, seen from above as it soars in the air. The sweep of the wingspan was done in a single stroke. The brush was filled with autumn brown and tapered on to the paper, along the bristles, to form the left wing tip. I then moved the brush across the wingspan, turning it until I was working across the bristles, and tapered it off to form the right wing tip. The body and head were then put on and the tail added with a series of small strokes, across the bristles, working towards the body. Lastly, I added the black markings with the tip of the brush.

Fig. 58 Eagle

For **Fig. 59** I worked directly in burnt sienna. Ducks do not fly in the same way as eagles and, this time, I began with the head, neck and body. Next, I painted the nearer wing by laying the brush against the body and turning and tapering the stroke outwards, across the bristles. The duck's back and the second wing were then put in, and some strokes added to the tip of the first wing to make it larger. Finally, I added the black markings and the feet.

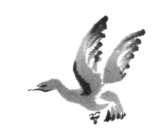

Fig. 59 Duck

For the gull in **Fig. 60** I made dark grey by mixing a little white with black ink, and then put in the wings, working along the brush-head and tapering the stroke on to and off the paper. The head, body and tail were added, then the black markings put on and highlighted in a few places with white. Had I used the usual method of making grey, by mixing ink with water, it would have run when the white was added.

Fig. 60 Gull

I usually use flying birds in my paintings but you may want to have some small birds sitting in trees, and I have provided some examples in **Fig. 61**. Even more than with flying birds, it is important to keep detail to a minimum or there is a risk that the birds will dominate the foreground of the painting. I used burnt sienna to make the shapes of the birds with dabs of colour, adding markings in black.

Fig. 61 Sitting birds

Fig. 62 shows some examples of the shapes typical of birds seen flying in the distance. The wings were done with a tick movement, the brush tapered down on to the paper along the bristles, turned and tapered off. I then added the heads and tails, and a little black for emphasis.

Fig. 62 Distant flying birds

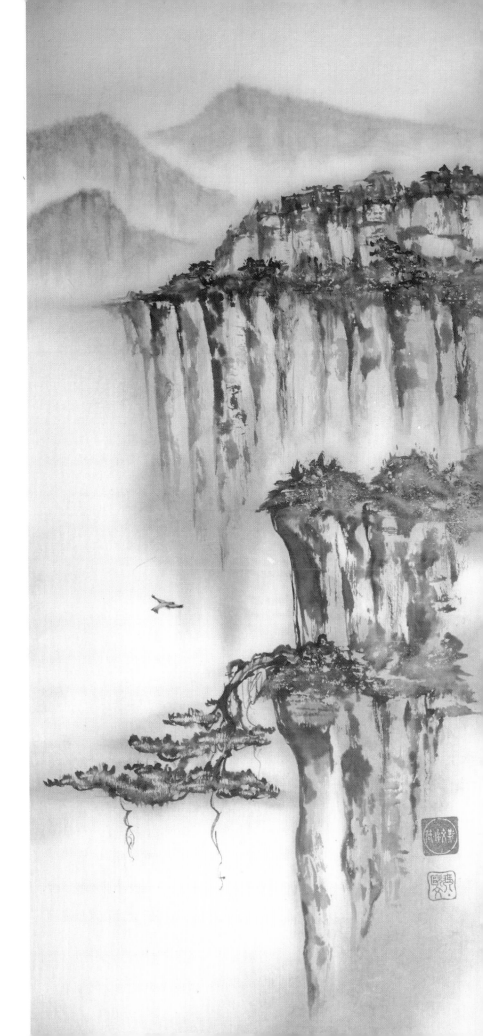

River Célé, Lot, France: 3,
88 × 42 cm (34½ × 16½ in)
A little further along the river
from the scenes in **Figs. 73** and
74 you come to the stretch of
cliff shown here. This time I have
tried to show the scene earlier in
the morning when the thick, cool
mist hanging over the river totally
obscures the far bank. This is a
scene that I have painted several
times and I confess that in this
picture the cliffs are somewhat
stylized. However, in spite of
this, or perhaps because of it,
this version best captures the
spirit of the place for me. I used
the bird as an artistic device,
depicting it from above to
increase the sense of the
valley's depth.

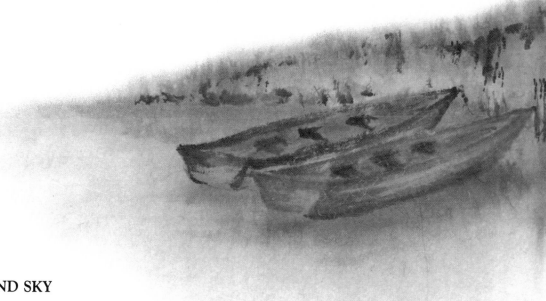

WATER AND SKY

Books on traditional methods of Chinese landscape painting
occasionally contain sections on waves and clouds but these
are usually just shapes drawn with the tip of the brush.
Perhaps because they wanted their paintings to have a
timeless stillness, traditional Chinese landscape painters
usually left water and sky to be supplied by the eye of the
beholder. At most they would add a light tone wash to
these areas of a painting. Modern Chinese painters have
become more interested in depicting water and sky. For me,
they are frequently the main source of inspiration.

Inland waters

For still water and waterfalls I compromise between the
traditional Chinese way of leaving the paper blank and the
Western custom of adding colour. Water itself is usually
colourless, merely reflecting the colour of its surroundings
or of the sky. I normally show still water, therefore, by
putting in a reflection of the surrounding land and leaving
the body of the water untinted. Occasionally I add a hint
of the sky colour to the water. For waterfalls, I generally
just add some light shading in places.

In **Fig. 63** the whole picture was done in grey and
black ink before any colour was added. I began by painting
the boats, using the method described for **Fig. 53**. The
steps were put in next. Then I changed to a 4 × 1 cm
(1½ × ½ in) coarse brush and put in the bank, using the
technique described for the short grass in **Fig. 37**. The tall
grass in the foreground was added (see **Fig. 36**) and some
autumn brown run over the boats.

Once the ink and autumn brown were dry, the paper
was damped and some grey ink was blended in to provide

shading on the bank. Using a soft 3 × 1 cm (1¼ × ½ in)
brush, I added the shadow under the boats and the
reflection of the bank in the water, and put in the shape
of the sandy beach. Next, I blended indigo, rattan yellow
and burnt sienna over the bank, diluting this slightly
and adding some of it to the reflection. Rattan yellow,
toned down with a little autumn brown, was brushed over
the sand, and a light mixture of indigo, sky blue and
burnt sienna was blended into the sky, with the colour
concentrated round the edge of the picture and close to the
bank. Some of the same colour was added to the foreground
of the water, concentrated behind the reeds and carefully
blended. I then put on some concentrated light green to
highlight some of the grass, and blended a little white on
to the boat.

Fig. 63 Still water with boats

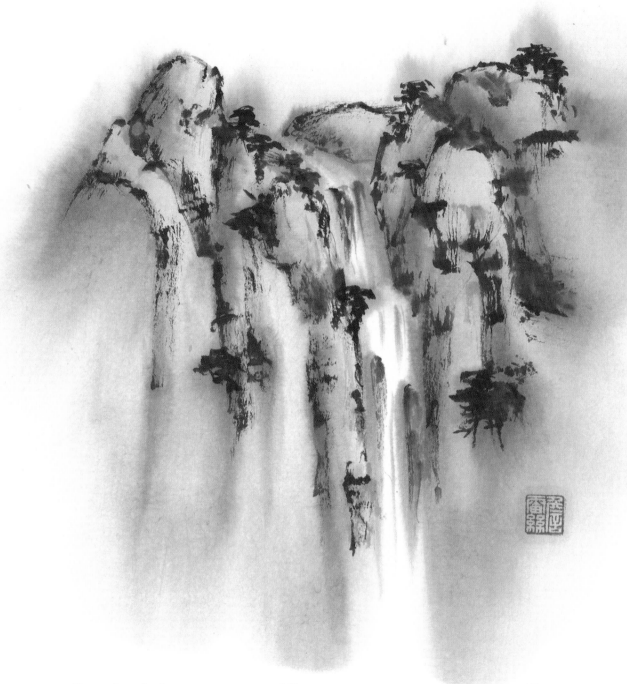

Fig. 64 Waterfall

Even though the water in a waterfall is moving, you can use the same minimalist approach to depict it, relying on the eye of the beholder to supply the movement. The rocks surrounding the waterfall in **Fig. 64** were done using exactly the same method as for **Figs. 39** and **40**. I added some small areas of rock to the space left for the water, tapering these to give a feeling of downward motion. Using a 3 × 1 cm (1¼ × ½ in) soft brush, I also ran some shading down the side of the waterfall and extended the rocky areas. I was careful to leave some of the waterfall untinted when adding colour, confining myself to bleeding a little colour over the areas already inked.

Moving water

You quite often see Chinese paintings which have waves drawn on in ink, as in **Fig. 65a**. I do not like this method of showing water because, unless it is very well done, it can make waves look flat and immobile. If you choose this style, keep your brush strokes very free and dramatic to impart a sense of movement. You can soften the effect by using lighter ink and working on damp paper (see **Fig. 65b**).

I prefer to depict movement in water by blending colours on to damp paper (see **Figs. 66, 67** and **68**). For the lapping waves in **Fig. 66**, I covered the area with a mixture of indigo and sky blue, toned down with a little autumn brown, putting the colour on with a 4 cm (1½ in) wash brush. I applied a very little at a time and blended it across the paper. The colour was concentrated in swathes, so that some areas of paper were left with hardly any. Some more sky blue and a touch of rattan yellow was then added to the colour and blended into some of the lighter areas, leaving others clear (**Stage 1**).

A thicker, darker version of the original colour mixture was used for **Stage 2**. I drew the waves with the tip of a plum blossom brush, blending them into the surrounding paper with a clean hake brush, and then ran a little Chinese white along the top of a few waves, blending it in the same way.

Fig. 65 Drawn waves

Fig. 65a

Fig. 65b

Fig. 66a Stage 1

Fig. 66b Lapping waves: Stage 2

The base colour for the ruffled water in **Fig. 67** is a mixture of indigo, sky blue and autumn brown. Using a 4 × 2 cm (1½ × ¾ in) firm brush, I put the colour on to the paper with broad, sideways sweeps of the brush, using the full length of the bristles and working across the brush-head. I then blended the whole area with a clean wash brush (**Stage 1**).

I have separated out Stages 2 and 3 for the purpose of demonstration. However, in practice, I blend the colour as I add it to the paper. For **Stage 2** I drew in small waves with the tip of my brush, using a thicker, darker mixture of the original colour. I then added some white highlights. The shapes in the illustration here do not look as distinct as they did when I first put them on because the wetness of the paper caused them to blur. However, you can still see the difference that is caused by blending the strokes with a clean wash brush for **Stage 3**.

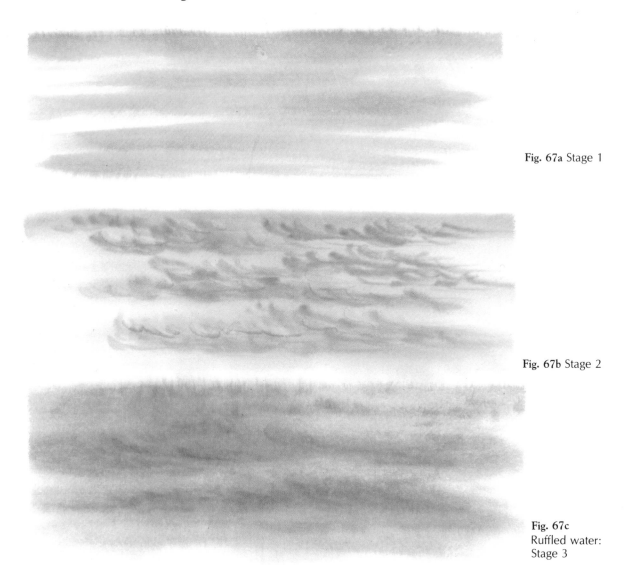

Fig. 67a Stage 1

Fig. 67b Stage 2

Fig. 67c
Ruffled water:
Stage 3

To paint the rough sea in **Fig. 68**, I put in the rocks
in the usual way, being careful to make them fade away
towards their bases where I intended to add water. Once
the ink had dried, I damped the paper and put the shading
and colour on to the rocks. When this too was dry, a
mixture of indigo, sky blue and autumn brown was put on for
the darker waves with a bamboo brush and blended in with
a clean wash brush. I made the colour slightly darker by
adding more indigo and autumn brown, and blended it
into the curves of the waves and around the rocks. The
tone was lightened by increasing the proportion of sky blue,
before lighter waves were added in the same way (**Stage 1**).

In **Stage 2**, Chinese white was put along the tops of the
waves and blended in as usual. Then I changed to a very
small, 2 × 0.25 cm (¾ × ³⁄₃₂ in) coarse brush, filling it
with gouache white and splitting the bristles. I tapered the
brush down on to the paper to create the spray, blending
each stroke in gently and adding some more dabs of white
which were left unblended.

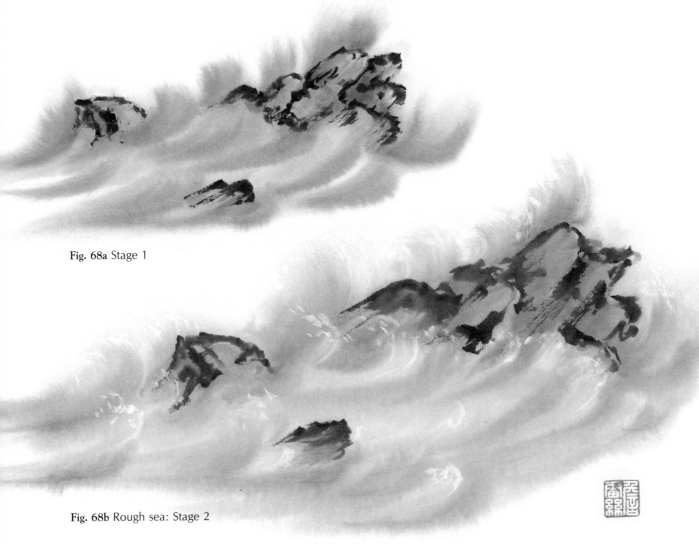

Fig. 68a Stage 1

Fig. 68b Rough sea: Stage 2

Skies

If I want the viewer to concentrate on the scenery in a painting, I often use gentle colour washes for the sky, blending in areas of dark or light tone and varying the colour depending on the mood of the particular painting. *St Cirque-la-Popie* (**Fig. 76**), *Glastonbury Tor* (**Fig. 78**), and *Windmills in Holland* on page 105 show examples of paintings where I used the sky wash to enhance the atmosphere of the painting without making it a main element. Sometimes, however, the sky is a major part of the scene (see **Figs. 89** and **90**). The figures in this section show the basic methodology involved in depicting skies, although I have not attempted to cover all the possible variations. Later chapters provide more examples.

I always work on lightly damped paper when painting sky. Any effect which requires careful blending takes time because you must add only a very little colour at a time. If your paper starts to become too dry while you are working on it, redamp it.

Fig. 69 shows a clear sky with a few clouds scudding across the moon. Having damped the paper, I made a small, solid circle in Chinese white and blended the rim gently outwards into the surrounding paper. The centre was thickened by blending in a little gouache white, and a halo of watery Chinese white was run round the outside of the moon to enhance the effect.

I then blended a mixture of indigo and autumn brown over the paper with a hake brush, taking care to apply only a little colour at a time and blending each brushful out as far as it would go before adding more colour. I varied the direction of the strokes to avoid streaks. I added new colour in an area already covered and worked outwards, keeping the area surrounding the moon fairly free of colour. A slightly darker tone was blended into a few areas, and a thicker mixture of the same two colours used for the clouds, which were painted with a plum blossom brush and blended gently with a clean brush.

For the evening sky in **Fig. 70** I brushed rattan yellow, toned down with a little vermillion and some Chinese white, over part of the paper with a wash brush. Some more vermillion was added to the colour to create darker areas, which were well blended into the yellow areas and the clean paper with sideways strokes to give a streaky effect. Next, some bloddy red was added and blended in, in the same way. Adding a tiny bit of indigo and some autumn brown, I then put on a few dark streaks with a bamboo brush. Finally, I added some streaks of dilute Chinese white to some of the lighter areas.

Fig. 69 Clouds across the moon

Fig. 70 Evening sky

Fig. 71 shows two different ways of doing clouds. For **a**, I filled a 4 × 1.5 cm (1½ × ⅝ in) soft brush with a mixture of indigo and autumn brown, darkened with a tiny bit of black ink. The full length of the brush was pressed firmly on to the damp paper and rolled to form the cloud shapes. The head was raised and pressed, but kept in contact with the paper. I blended the colour with a clean wash brush, making it slightly darker in a few areas. Finally, with the tip of the soft brush, I ran a little Chinese white along the undersides of the clouds.

Essentially the same method was used to paint the clouds in **b**. However, before applying the dark tone, I made a dilute mixture of Chinese white and sky blue, toned down with a little autumn brown and indigo, and applied this to the paper in a light, even, all-over wash. This gave the clouds a slightly mistier appearance.

Fig. 72 shows one technique for suggesting rain. Two mixtures of autumn brown, indigo and sky blue were used, one slightly darker than the other. I picked up a little of the lighter colour with the tip of an almost dry hake brush and dipped one side of the tip into the darker tone. Using the full width of the brush, I made long streaks of colour, tapering the brush off the paper. Some of the strokes were reinforced with a little dark grey.

You will notice in the following chapters that I often include areas of low cloud and mist in my paintings. As I explain later, these are usually conveyed by the absence of colour.

IN CONCLUSION

In this and the previous chapter I have tried to provide you with a foundation in basic Chinese brush painting methods. I have also included a few of the technical adaptations and innovations which I use most frequently.

The rest of this book describes the ways in which I have combined some of these techniques to depict scenes. I hope the paintings give you some new ideas.

Fig. 71 Clouds

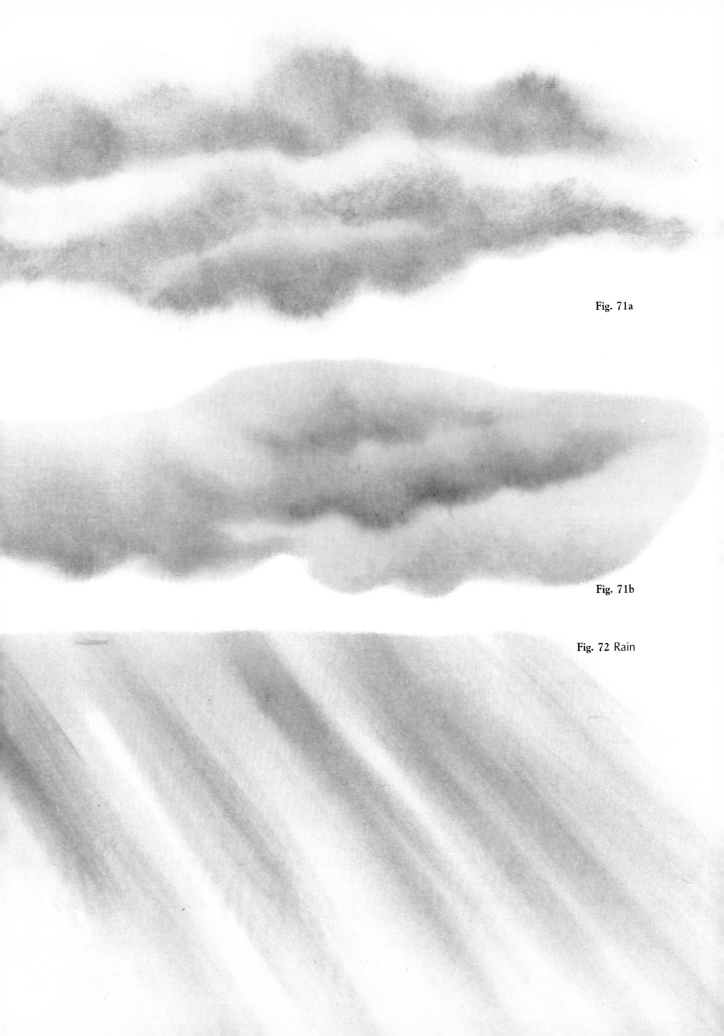

Fig. 71a

Fig. 71b

Fig. 72 Rain

GORGES & RIVERS

山峽及江河

I have always loved mountain scenery, particularly when the land has been shaped by the elements into spectacular valleys and gorges. Such dramatic scenes are particularly suited to the techniques of Chinese brush painting.

Rivers often convey an air of mystery to me. They may travel great distances through countryside and town, even under ground, moving inexorably to the sea. In places they gurgle and chatter, sometimes they race; the water may rush over rocks or swirl in gentle eddies. As rivers become wider they slow down, sometimes suggesting majesty and power, sometimes age and wisdom. I like to paint the way that mist can hang over the water, shrouding a valley and guarding the river's secrets even more closely.

RIVER CÉLÉ: 1

In recent years I have spent two holidays in the Lot area of France, where I have been particularly attracted by the limestone cliff formations along the banks of the River Célé. On both occasions I was there during the summer when the weather was very hot and sunny. However, in the early mornings a thick, cool mist would hang over the river until the sun burnt it off. In this painting (**Fig. 73**) I tried to capture the moment just as the morning mist is beginning to lift to reveal detail and colour in a still, damp landscape.

Looking at the rocky cliffs in the area, I was sure that some form of crumpled paper technique would be ideal to capture their texture. At first I experimented with the kind of random crumpling used for the bushes in **Fig. 74**. However, this did not adequately convey the vertical nature of the gorge and I decided to try folding the paper more carefully to control the creasing.

The illustrations in **Fig. 73** show how the painting was built up. Because of the nature of the freestyle methods I

Fig. 73a (BELOW) Stage 1
Fig. 73b (OPPOSITE TOP) Stage 2
Fig. 73c (OPPOSITE BOTTOM) Stage 3

use, there are variations between the versions. However, although Stages 1, 2 and 3 are not actual stages of the final painting, they do show the method used and the way in which I often work. I usually begin a new scene more than once, taking each picture a stage further until I am satisfied with the final version.

For **Stage 1**, the paper was damped evenly all over and then rolled lengthways into a narrow cylindrical shape. This was scrunched by squeezing it gently along its full length, then carefully unrolled. Most of the resulting creases ran lengthways but there was sufficient variation in direction to create the right texture for the rocks.

Using a medium soft brush, filled with light grey ink, I gently skimmed the surface of the creases to make the shape and texture of the foreground cliffs. I added dark grey ink in the same way. The more distant rock faces were put in with lighter tones.

Stage 2 was done while the paper was still wet, using a very large soft brush, filled with dark grey and tipped with black, which was pressed and rolled to make the foreground trees and the undergrowth at the top of the cliff. The brush was refilled with lighter ink, tipped this time with dark grey, to put in the far bank by rolling the brush along with the tip towards the river. I also added some texture for the trees and bushes, and put in the hills using the techniques described for **Figs. 45a** and **b**. Extra shadow was brushed on to the cliff and a reflection beneath the bank was put in. The painting was then left to dry.

In **Stage 3** the texture on the cliffs was reinforced by brushing over them with very black ink. Extra black texture was also put on the tree-covered area at the foot of the cliff. The distant rockface was emphasized with dark grey ink. At this stage I put in the canoe. Although I had never seen a canoeist on this particular stretch of the river, I had seen them nearby and I decided that it would be in keeping with the *chi* of the scene to include one. Essentially, the canoe was used as a device to emphasize the depth of the valley.

In **Stage 4** colour was added to the foreground while the paper was still dry. I deliberately encouraged the colour used for the bushes to bleed outside the inked area. Some white was put on the canoe, and colour added to the paddle and the man.

Once this colour had dried, the paper was damped and more colour was run over the far bank, the reflection, the hills and the sky, and blended with a hake brush. More dilute versions of the colours used on the cliff were used for the rest of the land. The colour was carefully blended so

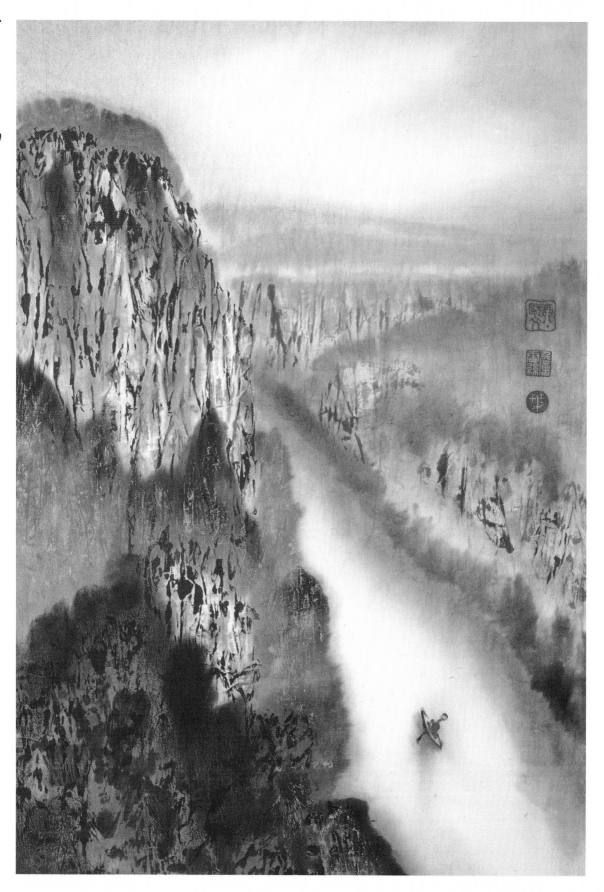

that part of the sky and most of the river remained white. A reflection under the canoe was added, first in grey ink and then in colour.

I waited for the painting to dry before adding extra texture by printing colour on to it, daubing a thick mixture of Japanese light green, Chinese light green, gouache white and yellow ochre on to a small sheet of Perspex – in fact, the lid of a music cassette – and pressing it down on to the lighter tree-covered area in the foreground. This was repeated on the darker area at the base of the cliff, this time using thick black ink. The printing combined with the creasing of the paper to give a particularly interesting and realistic effect.

By the time this painting was finished it was looking very tatty. The only way to get the creases out was to mount it, using the method described on page 140. This had to be done very delicately because the paper had worn thin in places.

Fig. 73d (OPPOSITE) *River Célé, Lot, France: 1,* 67 × 46 cm (26½ × 18 in): Stage 4

RIVER CÉLÉ: 2

The painting in **Fig. 74** again shows the morning mist over the River Célé breaking up as the sun's heat gets to work. This time I wanted to experiment with the effect of using the crumpled paper technique to suggest trees and bushes.

The foreground cliff was put in first, using across-the-bristle strokes of a very large coarse brush, leaving space for the foliage. The trees that were growing out of the rock were added with the tip of the same brush, the leaves stabbed as for **Fig. 33e**.

Next I put in the more distant cliff, using lighter tones of ink than before, and adding a suggestion of grass and bushes along the top.

The distant hills were added on damped paper, as described for **Fig. 45b**. For the other bank of the river, texture was brushed lightly on to the paper across the bristles of a coarse brush, and the effect of darker vegetation was achieved by laying the brush vertically on the paper. At this stage, too, I added the light ink reflection of the far cliff.

The paper was then allowed to dry before being redamped, the lower left-hand corner screwed into a tight ball and then carefully unfolded. With a medium soft brush, first grey ink and then black was skimmed across the creases to create texture for the foliage at the foot of the cliff. I then repeated this process with colour.

Once the picture had dried, I added some crisper texture to the bushes by skimming ink and colour over the creased area again.

On redamped paper, I ran dilute colour over parts of the cliffs, bleeding and blending it over the whole rock face. A hint of this colour was added to the far bank and to the reflection. The rest of the wash was brushed over the foliage, the bank and the hills, and blended into areas of the sky and water.

When the paper was dry a little neat Chinese green was dabbed over the foreground bushes with a small open-textured natural sponge. I put a little thick Chinese green on the leaves of the overhanging trees with the tip of a medium coarse brush. Last of all I added the birds.

The more often I paint a scene, the more I am prepared to leave out detail or just to hint at it. By uncluttering the view in this way, the real nature of a place can often be revealed more clearly. This particular scene is one that I have painted several times and I was particularly happy with this version.

Fig. 74 *River Célé, Lot, France: 2,*
84 × 47 cm (33 × 18½ in)

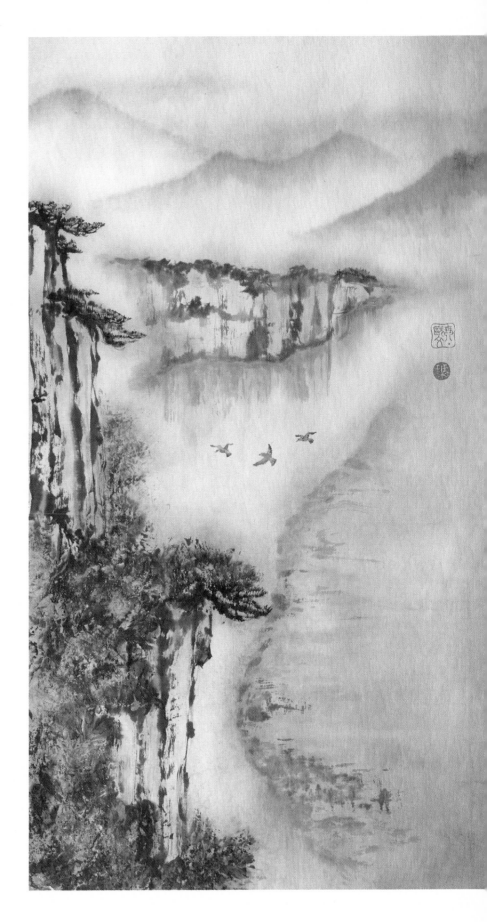

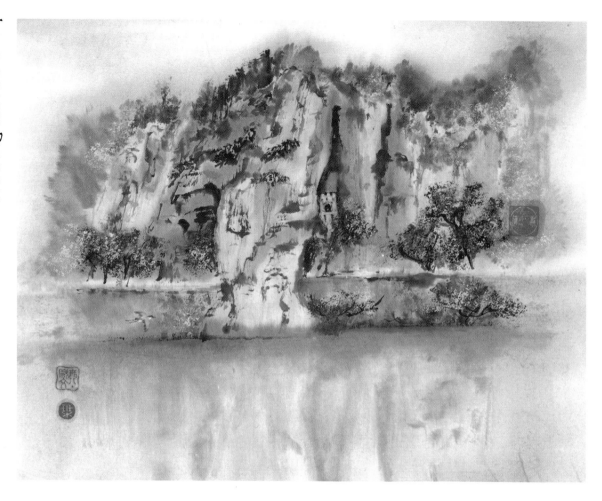

RIVERSIDE FORTIFICATION

The valleys of the Lot and the Célé are dotted with castles and fortifications set against the backdrop of the limestone cliffs. Most of them were built in the Middle Ages to defend the valleys against the English. Driving beside the Célé, I came to a place where the road goes through a natural archway in the rock. Nestling in the arch, some distance above the road, was a fortified tower built from stones the same colour and texture as the cliff face.

Fig. 75 is my attempt to convey the harmony between the man-made structure, weathered over the centuries, and its natural surroundings. I crossed to the other side of the river to get a better view.

This painting breaks the traditional rules of composition for a Chinese landscape. Although the water could be deemed the foreground, it is not prominent and, unless you count the sky, there is no distance at all. The focus of the picture is on the middle ground.

The buttress of rock that juts over the road and down into the river was done first, using a medium coarse brush

Fig. 75 *Riverside Fortification, Lot, France, 47.5 × 61.5 cm (18¾ × 24¼ in)*

worked across the bristles. A little undergrowth was added with 'scrubbing' strokes done with the brush tip.

The tower was positioned by drawing it in very light ink with the tip of the brush, followed by the rest of the cliff, leaving spaces for the trees. The ink tones were gradually lightened as I worked away from the buttress to give the impression that it was looming out of the morning mist. Some undergrowth was added to the cliff, and a few bushes and trees along the top. More bushes were dabbed on with a close-textured sponge and light ink. I did the tower in black ink and added the trees at the foot of the cliff.

The wall running along the edge of the river was put in with a small sponge paint roller, 3.5 cm (1⅜ in) wide. This was loaded unevenly by dipping it first into grey ink so that about half the sponge was covered and then adding a little black to the edges. I rolled the ink on to the paper, using two parallel strokes to create the wall, then reloaded the roller and added some vertical strokes for extra texture. I reinforced the top and bottom of the wall slightly with my brush.

The paper was damped before more bushes were put along the top and round the sides of the cliff with the sponge. I extended the cliff slightly with the brush and blended in shadow. The ink tones for the reflection were added and the water's edge darkened.

Next, colour was added on the rockface, tower, undergrowth, trees, sky and water. More dilute tones of the same colours were blended into the water for the reflection.

When the paper had dried, I put on the heron and added some highlights to the trees and bushes.

ST CIRQUE-LA-POPIE

As well as the spectacular cliffs, rivers and hills that make this part of the Lot so enjoyable to paint, there is the attractive romanesque architecture. The walls of the buildings are typically made of time-worn, rough, rosy brown stone with sun-bleached timbers, and the rooves are covered with rich reddish-brown tiles. Churches with circular or triangular pointed-roofed towers dot the countryside. Because of the steep and broken nature of the terrain, the buildings in the villages and hamlets cluster together in a charming, higgledy-piggledy way.

St Cirque-la-Popie is one of the prettiest villages in France and combines all the attractive features typical of the region. It sits atop an outcrop dominating the valley below, surrounded by hills. The church has a double tower

which seems to combine square bits with round ones, a circular roof with a triangular one, in a wonderfully ad hoc fashion. The buildings are old and weathered, the streets are narrow and steep. Such picturesqueness, means the village is also full of souvenir shops and tourists! However, when you look at St Cirque from the other side of the valley you see only a small mediæval town that has basked peacefully in the sun for centuries.

In order to get the village in **Fig. 76** reasonably accurate, I began by establishing the outlines of the buildings. To avoid harsh lines I damped the paper lightly before drawing in the shapes with very light ink, using the tip of a plum blossom brush.

When the paper had dried, the foreground cliff face was done with sideways, dry strokes of a medium coarse brush. I put on some more grey ink with a wet brush for added contour and depth.

I used a damp, open-textured, natural sponge to establish the general shape and texture of the vegetation round the base of the cliff, on the ledges and between the houses. I put in branches and extra squiggles in black with the tip of my coarse brush. The buildings were highlighted with black ink, and dimension added by placing the emphasis to suggest shadow.

The paper was damped all over before the distant hills were put in. There is a small area of exposed rockface on the hill to the right of the painting and for this I used the technique described for **Fig. 44**. The other hills were done with a very large soft brush rolled on to the paper in the usual way. Using sideways sweeps of the same brush, I dragged some light tone downwards to give a suggestion of a cliff on the right of the painting. Vegetation was added to the bottom of this with a sponge. I also added vegetation around the base of the main cliff.

Using a soft brush, I ran some light ink into the shaded areas of the buildings and blended colour on to the rock face. I brushed Japanese dark green and vermillion over the vegetated areas, blending the colour out over the edges of the inked areas to create a misty effect.

The colour over the rooves was allowed to bleed so that it gave a rosy glow to the town. For the walls, I varied the colour mixture slightly on different buildings.

The paper was redamped for the final wash. I blended colour into the sky and round the edges of the vegetated areas, leaving large areas with no colour except the little they acquired in the blending, and varying the tonal mixture. Finally, I concentrated orange and yellow tones at the top of the hills, round the town and in parts of the sky.

Fig. 76 *St Cirque-la-Popie, Lot, France*, 103 × 46 cm (40½ × 18 in)

The Ardèche Gorge, France, 68 × 46 cm (26¾ × 18 in) The Ardèche Gorge in southern France is on a truly grand scale. Since I did not spend much time there my painting is an immediate response to the scenery. Because of this, I hope that it has freshness and directness. I chose to paint this particular view for the simple reason that I liked the shape of the pillar in the foreground and because it offered an interesting variety of rocky cliff formations. My aim was to convey the grandeur and majesty of the valley of the Ardèche. As a finishing touch I added the Chinese character for mountain and the date, 1988.

RIVER MORRISTON

Early one stormy April afternoon I came across the scene in the Scottish highlands depicted in **Fig. 77**. I was struck by how icy the water looked and by the way that the cold seemed to be draining the landscape of colour, which gave the scene a bleak appearance.

I laid my paper over a second sheet of *shuan* before damping it all over, hoping to create extra texture where the two sheets stuck together. I filled a very large soft brush with light ink and tipped it with black, then rolled it on to the paper, pressing and lifting to block in the foreground and hills. I created the effect of tree cover on the left bank of the river by pressing the brush vertically on to the paper several times. The distant hills were done with lighter ink. As I had hoped, the two sheets of paper stuck together unevenly, creating an interesting appearance of undergrowth on the land and of rock shapes on the mountain.

While the paper was still damp, I ran some colour over parts of the river banks. This too picked up some texture

from the second sheet of paper. I then put the painting aside to dry, separating the two sheets once I was sure the texture had 'set'.

Next I added the telegraph pole, the trees and the rocks and highlighted a few of the trees with gouache white. I used a small soft brush for the trees and the pole and a small coarse brush for the rocks.

Once the ink had dried, I redamped the paper and added the reflection in the water with light ink, using a small soft brush. I gently drew in some wave lines around the rocks in the water.

I washed autumn brown and vermillion over the land in the foreground and blended thick Chinese green on to the rocks. I added colour over the reflection and around the rocks in the river and ran thicker colour over the mountains. I ran a little Chinese white into the snowy areas and blended some gouache white movement lines into the water where it runs over and round the rocks.

I did the sky by the method described for **Fig. 71b**, covering the whole area with dilute Chinese white before rolling the clouds on with my large, soft brush. A little gouache white was blended into the lightest parts of the sky. When the painting was dry, I mixed gouache white, yellow-brown, yellow ochre and carmine, and daubed this on to parts of the foreground with a wet fine-textured sponge.

Fig. 77 *River Morriston, Scotland,* 47 × 70.5 cm (18½ × 27¾ in)

LANDMARKS & MAN-MADE SCENERY

顯著地標及人造風景

People have higher expectations of paintings of familiar places than they do of less well-known places. They want to see their own feelings about a place reflected in the painting, but they also hope the artist will tell them something about the scene that they had not appreciated before. At the same time, they usually demand physical accuracy and realistic detail, and seem to be less willing than usual to allow for artistic interpretation.

Painting a well-known landscape therefore presents the artist with special problems. It may be more difficult to have a clear sense of the essential spirit of a scene because this is overlaid in your mind by knowledge of the location's historical and cultural significance. Inevitably these form part of your awareness of a place and you try to convey this information together with your personal response to the scene, which may have nothing to do with its history.

In one respect, however, having an instantly recognizable landmark in a scene can allow the artist more freedom. Because the landmark fixes the scene in the viewer's mind with comfortable familiarity, the painter can alter his perspective and viewpoint for the surrounding features without obscuring the identity of the place.

GLASTONBURY TOR

Glastonbury Tor in Somerset is a focus for a wonderfully rich and diverse vein of legend and mythology. It is situated in the heart of the Isle of Avalon which once rose out of the surrounding marshland. The people of the Middle Ages believed that King Arthur was buried in Glastonbury Abbey, one of the wealthiest houses in England before the dissolution of the monasteries. Some people still believe that Glastonbury is the site of Camelot, although more convincing claims can be made for other places.

Glastonbury also lies at the crossroads of the ancient ley lines which run from there to Stonehenge and to Tintagel. Not surprisingly, the town has become the centre for every sort of mystic activity and pilgrimage.

When you look at the tor at certain times it is easy to imagine the legends coming to life, and I wanted to convey some of this aura of mysticism in my painting. However, overriding this was the feeling that Glastonbury Tor means other, much more prosaic, things to me personally. Since my school days it has, above all, meant the approaching end of a long journey. It dominates the surrounding landscape and can be seen for miles. On occasion I have used it as a landmark, literally to find my way by. It provides a constant backdrop to any activity in the area and I have memories of muddy scrambles up and down the tor itself. It even reminds me of the shoes I wore as a child which had a picture of the tower stamped inside them.

In my painting of Glastonbury Tor (**Fig. 78**) I wanted to convey a sense of the tor rising out of the evening mist, like a beacon in the distance presiding over the surrounding countryside, as it has done for centuries past.

I decided to alter the viewpoint slightly to show the curve in the dyke without changing the position of the tor and the trees. For **Stage 1**, I did a section of the foreground area on dry paper. I began with the tree, using a medium coarse brush to put in the trunk and the branches. I used the basic technique described for **Fig. 33c** for the leaves, 'scrubbing' the stroke slightly as I laid the brush down.

Fig. 78a Stage 1

Fig. 78b Stage 2

I did the bushes at the foot of the tree by the method described for **Fig. 35c**, using a small natural sponge with a fairly open texture. For the grass round the foot of the tree and at the base of the bushes, I used the technique described for **Fig. 37**. I also put in the fence and added texture to the ground, and then added the grass under the fence and along the top of the bank.

The rest of the painting was worked on damp paper. Once the foreground detail had completely dried, I damped the paper all over before establishing the main character of the scene in **Stage 2** (see previous page).

A large semi-coarse brush, filled with light grey ink and tipped with dark ink, was used to put in the dyke. I added the reflection of the bank, blending the ink downwards so that the reflection appeared to hang in the water. Next, I put in the reeds, again pulling the ink downwards for their reflection. Some shadow was blended into the land and texture added to the ground with darker ink. Lighter bushes, behind the existing ones, were put in with the sponge and a small amount of grey ink was blended around the leafy parts of the tree.

The texture on the water's edge of the far bank was created by laying the brush, half-loaded with darker ink, tip downwards, pressing lightly and lifting the brush cleanly off several times. I used my coarse brush for the trunks of the three tallest trees and the sponge for the foliage. Then I added the other trees, gradually lightening the ink tones as they got further away.

The hills below the tor were put on with the large semi-coarse brush, using the method described for **Fig. 45b**. I blended the ink downwards with the wash brush and added some slightly darker areas where appropriate.

The tor itself was done in the same way. Because I wanted to show how it looms somewhat over the countryside, I broke the normal rule about tones getting fainter in the distance and used slightly darker ink than I had for the nearer hills. I added the small clumps of trees on the crest of the hills using my coarse brush and the technique for distant trees (see **Fig. 34f**).

Last of all I put in the tower, being careful not to make it too large. It is easy to do this inadvertently when a distant feature is central to the composition of a painting.

When I added the colour wash (**Stage 3**), I started once again with the foreground, blending light shades of colour into the areas where I had already created tone with ink. The foliage of the trees is slightly bluer in tone than the ground. I blended carefully with a clean wash brush so that areas of the picture were left light for the mist.

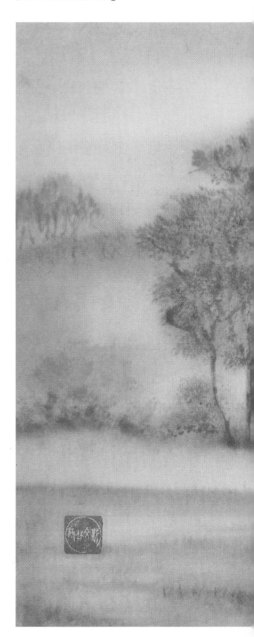

Fig. 78c *Glastonbury Tor, Somerset,* 48 × 83 cm (19 × 32½ in): Stage 3

The sky was washed with the same colours but because there was no underlying ink tone it looks lighter. Again I took care to blend carefully so that some areas remained clear. I blended a little Chinese white into the places where the mist was densest.

Using my coarse brush, I added some strokes in neat Chinese green to the reeds at the water's edge, the leaves of the tree, and the grasses in the foreground. Some light green was put on the three tall trees on the left of the painting with the sponge.

Finally, once the painting was completely dry, a few more grass strokes were added, some in black and some in light green.

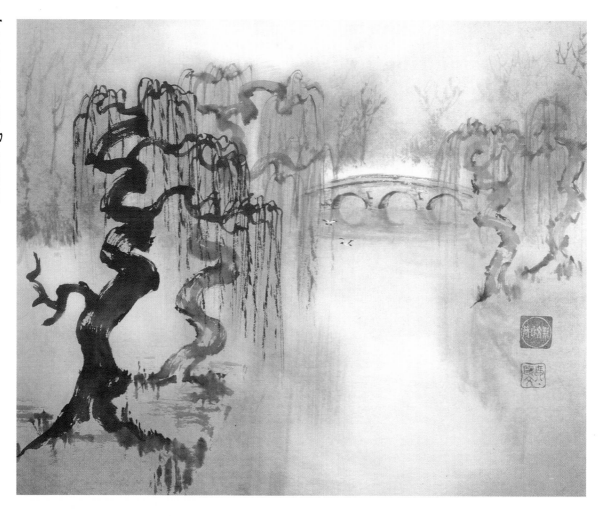

TRINITY COLLEGE BRIDGE, CAMBRIDGE

Fig. 79 *Trinity College Bridge,
Cambridge*, 45 × 56 cm
(17¾ × 22 in)

Unlike the impact of a new scene, which can be clear and
immediate and therefore sometimes easier to respond to in
a painting, my feelings about places that I know very well
are often complex, and therefore more difficult to express.

When I think about 'the backs' in Cambridge (the
stretch of lawns and gardens on both sides of the River
Cam behind the colleges), a host of jumbled memories
and impressions is conjured up. I remember punting in
the summer, May balls and parties to celebrate the end of
exams when I was a student. I think of plays and concerts
and leisurely strolls in more recent times. I remember
trailing patient visitors round Cambridge in the rain. On
occasions, I have stood and stared at the water or fed the
ducks. At other times I have hurried past on my way to
the library or shops. In spring the backs are vivid with
the colours of crocuses and daffodils and the willow is
bright, crisp green. In summer they are full of noise and
people eating ice-cream, and the trees look dark, cool and

a little dusty. In autumn the leaves turn golden and the
sun is hazy. In winter the fenland mist takes over and the
air can be grey and still, the willows hang dankly down
in the creeping chill and the only people to be seen are
going briskly about their business. This is the time to hurry
home and toast crumpets over the fire. When I painted the
picture in **Fig. 79** in February, it was the dank, misty cold
of a Cambridge winter that was uppermost in my mind.

In earlier versions of this painting I put in too much
and lost the sense of chilly, damp stillness that I was
striving for. When you depict a familiar scene in mist
from memory, your mind tends to supply the details that
the fog obscures.

The painting in **Fig. 79** shows the view of Trinity Bridge
that you get if you stand slightly to the left of centre on
Garrett Hostel Bridge. However, for the willow trees on the
left bank, I altered my viewpoint and these are seen as if
from the lower ground of the path (see page 9).

The painting was begun with the dark willow tree in
the foreground, using a medium, semi-coarse brush. I
wanted the tree to stand out starkly from the mist, and to
achieve the gnarled, twisted effect with a single stroke. I
therefore filled my brush with black ink straight from the
stone and did the main shape of the tree, beginning at the
top and working downwards, completing it with a single
movement. The side branches and the leaf fronds were put
in as described for **Fig. 25**, with a few small dabs added to
suggest old leaves or buds.

I did the other willow trees with similar strokes but used
shades of grey ink and added some darker accents. I put in
a very small amount of ground texture in the foreground.

Next, I put in the bridge, using the technique described
for **Fig. 48**.

Damping the paper in the usual way, I added the trees in
the distance with a small coarse brush. I did not add leaves
to the trees themselves because it is a winter scene, but I
put in a few very light bushes with a sponge. Then the
reflections of the bridge and trees were added, and blended
with downward strokes of a clean wash brush.

Before putting on colour I redamped the picture. The
wash was concentrated in areas where there were trees,
ground or reflections, and the colour blended out from
there into the clear areas. The bridge was highlighted
by leaving the area immediately above it free of wash. I
emphasized the divide between the bridge and its reflection
by putting in a line of slightly more concentrated wash tone
and blending it down into the water. The gulls were put in
once the wash was dry.

BRIOUDE

Fig. 80 *Brioude, France,*
48 × 83.5 cm (19 × 32¾ in)

I was predisposed to find Brioude in the Haute Loire in France attractive because a photograph of part of it is featured on the front of a map I bought before going to the area. The town more than lived up to expectations. The photograph had failed to show the way it hugs the valley side at the foot of the hills. It is built of attractive weathered stone with rich red and brown rooves, and the buildings stand out against the lush green vegetation.

The scene in **Fig. 80** is depicted from two viewpoints. If you stand facing the main part of the town, you actually need to turn slightly to be able to see the bridge and the houses on the left of the painting from the angle shown here.

The buildings were put in with a plum blossom brush, following the method shown for Stages 1 and 2 of **Fig. 46**.

Having damped the paper, the trees in the foreground were then put on, using a small close-textured sponge for the foliage and the plum blossom brush to add trunks and branches. I used a very small sponge to put trees in between the houses.

The shapes of the hills were made with a very large soft brush, filled with grey ink mixed with a hint of indigo, using the methods described for **Fig. 45**. I added an impression of extra trees to parts of the closer hills and round the isolated houses. Using a medium soft brush, I ran grey shading on to appropriate parts of the buildings

and then left the painting to dry before adding colour to the buildings. Still with the paper dry, I used the very small sponge to add colour to the trees between the buildings and a larger sponge for the trees in the foreground.

Once the colour had dried, I damped the paper evenly all over and colour washed the tree areas. Most of the colour was put on in the usual way by blending it with a hake brush, but some extra wash colour was applied in places with the sponge. Then I washed the hills and sky.

When the paper was almost, but not quite, dry, I put on the light tree trunks with gouache white, using a medium soft brush. Gouache black was used for the markings, which were done in the manner of **Fig. 28**, but I substituted wet, white paint for plain water. I used gouache black, rather than ink, because I wanted to work it in while the paper was still wet. Ink would have diluted and bled too much for the crisp, very black effect that I wanted. Still using gouache black, I added a few extra tree trunks and branches.

Lastly, I used the larger sponge to dab opaque colour on to the lighter foreground trees; I also sponged on a little gouache black.

NÔTRE DAME CATHEDRAL

I always feel more alive amidst the cosmopolitan bustle of a capital city. I also love France – as can be seen by the number of French scenes in this book – so I find Paris irresistible. More than most places, the city seems to reflect many moods. It can be both frivolous and serious, exciting and melancholy, romantic and businesslike. I recently visited Paris in mid-January when the weather was dreary and the famous sights bereft of tourists. It is this side of the city's character that I have tried to capture in **Fig. 81**.

Fig. 81 *Nôtre Dame, Paris,*
47.5 × 48.5 cm (18¾ × 19 in)

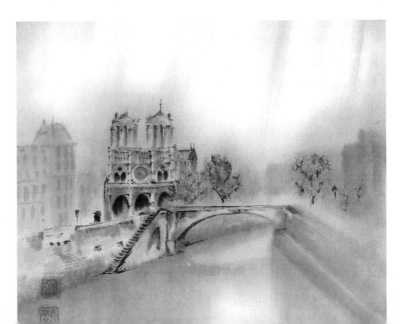

It is difficult to write about Paris or to paint it without resorting to clichés and I have not fought the temptation very hard here! Thus I have tried to relieve the underlying melancholy of this particular scene with the lighter note provided by the umbrella, and I have topped it off by including the biggest cliché of all – a pair of lovers by the Seine. There were a few couples strolling about, but whether lovers or not I could not really tell!

I began by putting in the cathedral, using a plum blossom brush and following the method described for Stages 1 and 2 of **Fig. 46**. Next, I put in the dry texture for the left bank and added the bridge and steps.

I made a strong solution of alum and painted it on to parts of the buildings, hoping that this would prevent the colour from taking properly and create soft highlights.

The foliage was done with a small close-textured sponge, and the trunks and branches added with a brush. The figures and umbrella were lightly positioned. The paper was then damped and the shadow and reflection were put in.

The rest of the painting was done in the usual way. However, because the alum resist had not worked as well as I had hoped, I added a little Chinese white to the building colour and highlighted parts of the cathedral and bridge.

The rain was done in the same colour as the sky and water, following the method described for **Fig. 72**. Last of all, gouache yellow was used for the lamp and carmine for the traffic light and the umbrella.

AMSTERDAM

My first visit to Amsterdam was made in the summer of 1990. I was immediately enchanted by this charming city, full of canals and bridges and leafy trees. The normal hubbub of city traffic seems to have been tamed by the slower pace and gentler sounds of the waterways. You can wander contentedly for hours beside canals, over bridges and down narrow streets crammed with interesting shops. Or you can sit in a café by the water and watch the world go by. The distinctive gabled buildings are not majestic but they are often elegant and sometimes fun.

The scene depicted in **Fig. 82** is on the edge of Amsterdam's infamous red-light district. Full of life and noise by night, the area seems like a quiet retreat by day. I visited it on a hot sunny morning and found leafy, cool stillness.

With this scene, as with the previous painting, it was very important to get the perspective correct. I noted

carefully the angles of the canal sides and the bridge as well as their relative sizes. I marked these in lightly with very dilute ink before doing anything else, then used a bamboo brush to put in the sides of the canal and the bridge properly, adding the fountains, lamps, convenience and buildings. The trunks and main branches of the trees were done with a medium soft brush (see **Fig. 30**). I added the foliage with a close-textured natural sponge, taking care not to make it too dense, and put in the other details.

Next, the paper was damped for the shading and the reflections, and grey ink was dabbed into the water with the sponge as a reflection for the trees. Then colour was added to the individual elements of the picture before the general wash. I blended very dilute sky blue over the sky and used a large soft brush to dapple dilute versions of all the colours I had used into the water, in the appropriate places for the reflections. Finally, I sponged opaque colour on to the lighter leafy areas to get the effect of dappled sunlight.

Fig. 82 *Amsterdam Canal,*
57 × 45 cm (22½ × 17¾ in)

FLATLANDS

平地

I must confess that I find flat land more difficult to paint than other scenery. When I analyse my feelings about a flat landscape that I enjoy, I often find that I am responding to insubstantial elements such as a sense of openness and space, or admiring a particular building or group of trees, or watching the changing light and the clouds in the sky.

Perhaps it is simply that I usually find mountains and hills, or water and sky, or rivers and gorges, more exciting to look at and, consequently, more interesting to paint. When I paint such scenes I can create an interplay of shape, texture and colour. When I am depicting a stretch of flat landscape, on the other hand, I lose the dimension of shape. The basic character of flatland is, after all, even and uneventful. Indeed, the word flat can be used in some contexts to mean monotonous. The only shapes that I can play with are trees, buildings, clouds, birds and animals – things that may be incidental to the essential nature of the scene.

However, some flat scenes I do find inspiring. There are some stretches of land where the sky seems to expand to reach the far horizon and where I feel a great sense of space and light. In other places, light and wind play through trees or over flowers, or buildings seem to stand on tiptoe to reach up into the sky. It is difficult to convey an impression of vast space in a painting. To use only texture and colour to capture what it is that makes an area of flatland unique is a real challenge for the artist.

Windmills in Holland,
48 × 76 cm (19 × 30 in)
Flatness is often a negative feature of a scene, removing interest from it. In Holland, however, the evenness of the ground is so pronounced that it becomes a positive element. The fields or polders are divided by dykes which ought to alleviate the flatness. Instead, they emphasize it because they themselves are straight and carefully laid out in orderly grids. The windmills are both a distinctive visual feature of the landscape and a vital element of it. Without their constant pumping, the land itself would cease to exist. I saw these windmills in the distance from the road between Amsterdam and the old university town of Leiden.

I made several versions of this painting, experimenting with distance. It is principally the windmills that give this scene its special character and, to begin with, I wanted to make them larger and more dominant. When I did this, however, the painting lost the sense of space and extreme flatness that I wanted to convey. I finally decided, therefore, to depict the windmills as, in fact, I first saw them – with a great deal of land and several dykes between me and them.

NORTH NORFOLK MARSHES

The stretch of North Norfolk coastal marsh shown in the painting in **Fig. 83** is well known to bird watchers because of the great numbers of water birds that congregate there. I wanted the birds in my painting to form an essential part of the composition, just as they seem to be an integral element of the landscape. I hoped that, by showing the birds in flight, I would increase the feeling of distance and space that is so characteristic of this part of the coast.

To emphasize the importance of the birds, I began **Stage 1** with the geese, using a plum blossom brush and the method described for **Figs. 59** and **62**.

I filled an extremely large soft brush with a mixture of bloddy red and peony purple, tipped it with ink, and created the foreground texture by sweeping the brush across the bristles. The tip of the brush formed the edge of the ditch. This process was repeated for the far bank, this time keeping the brush tip downwards. I fanned out the tip of the brush, dipped it into black ink, and added the grass with tapered strokes along the bristles.

The distant hills and buildings were done on damped paper with a large firm brush. A little indigo was added to the foreground colour for the hills to increase the sense of distance (**Stage 2**).

The sky was washed in, using the technique described for **Fig. 71b**, covering the whole area with light tone made by mixing white with a little cloeseed yellow and some burnt sienna. A mixture of autumn brown, bloddy red and peony purple was rolled on for the clouds. The same colour was used for the reflection and to darken some areas of the foreground (**Stage 3**).

Fig. 83a (LEFT) Stage 1
Fig. 83b (OPPOSITE TOP) Stage 2
Fig. 83c (OPPOSITE BOTTOM)
North Norfolk Marshes,
48 × 72.5 cm (19 × 28½ in):
Stage 3

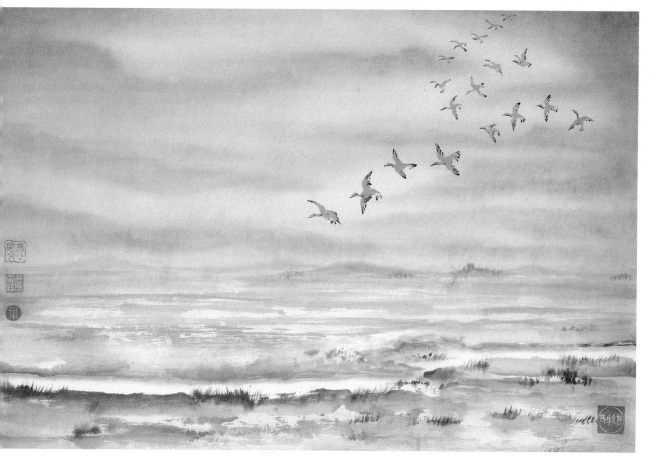

BULB FIELD IN CAMBRIDGESHIRE

The daffodils in the field depicted in **Fig. 84** were being grown for bulb production. Knowing this, it nevertheless seemed odd to find this blaze of glorious, unharvested colour away from the road and far from any houses. At first it was the massed, yellow flowers that attracted me to the scene. However, when I came to consider it more carefully, I realized that it was the juxtaposition of the darker colours and coarser textures of the hedgerow and those of the field, with the path between them, that I found so interesting.

Because I had decided to make the hedgerow the dominant element in the painting, I wanted to create plenty of texture in it and on the beside the field. I therefore cut a piece of smooth cartridge paper to the rough shape of the field, path and hedgerow. I placed this under my *shuan* paper, which I then sprayed with water to damp it. The *shuan* stuck to the cartridge paper in places.

Fig. 84 *Bulb Field, Cambridgeshire,* 47 × 55 cm (18½ × 21½ in)

Using a very large soft brush, I rolled, pressed and pulled black and grey ink on to the paper to make the shapes of the hedgerow, path, ditch and field, varying the textures. Because of the cartridge paper, the ink puddled in places, and interesting ridges and tonal variations were created.

With the tip of the brush, I put in the trees at the far side of the field, placing them above the line created by the edge of the underlying cartridge paper. While the paper was still wet, I added some rattan yellow to the field, using the same rolling and pressing movement, and brushed colour over the bushes and grass verges. Like the ink, the colours puddled and ran because of the cartridge paper.

I then put the painting aside to dry, leaving the cartridge paper in place until the effects it had caused had dried sufficiently to fix.

Next I added the trees. The pine was done with a small coarse brush, by the method described for **Fig. 26**. For the other trees I used a small soft brush and followed the method described for the maple tree in **Fig. 30**. With the coarse brush I added some grass, using the methods explained for **Figs. 36** and **37**, and some bushy texture was put on with a small sponge, following the method described for **Fig. 35c**.

When the ink had dried, I added a little colour to the tree trunks and put some texture on the path in colour with across-the-bristle strokes of a dry, coarse brush.

Colour was washed on in the usual way and Chinese green highlights added. Last of all, I sponged some gouache yellow on to the field and added a few dabs of thick yellow for the flowers in the foreground.

Landscape paintings can usually be divided into two broad categories: panoramas and close-ups. A close-up painting may even look as if it could be a detail of larger view. Most of my paintings seem to belong to the panoramic category but this one is a close-up.

RAPE FIELD IN LINCOLNSHIRE

I was tempted to put the painting of a field of oilseed rape flowers in **Fig. 85** into the previous chapter, since the appearance of the countryside has been dictated by modern farming practices. Increasingly, during the springs and early summers of recent years, East Anglian fields have become clothed in the harsh yellow of this alien crop. Although natural colours are often bright, they seldom jar. The strident yellow of the rape flower, however, is an exception. It is one of those colours that seem to need very bright light. When I look through the clothes that I wore when I lived in the tropics, I realize that I would never wear such bright colours under the more muted English sky. Similarly, the garish yellow of the rape flowers seems to demand strong, harsh sunlight and to be quite out of place on a windy, showery April day in England. Whereas the rich yellow of the daffodils in the previous painting complemented and enhanced the surrounding country, a field of rape shouts its presence and dominates its surroundings.

Even though I have mixed feelings about the way this invader has come to dominate the softer hues of an English spring, there is a certain splendour about the way the colour blazes out, and it is this that I have tried to capture here.

Using an extremely large soft brush on damped paper, I established the shapes of the land with sweeping strokes across the bristles, pausing and pressing in places to encourage the ink to run, and adding extra black texture to the foreground. My original intention was to do this painting entirely in shades of ink, apart from the yellow. I therefore put on the clouds at this stage, using the same brush filled with light and dark ink and rolling it on to the paper as I did for **Fig. 71a**.

When the paper had dried I added the trees and telegraph poles, using a small open-textured natural sponge for the foliage and a plum blossom brush for the trunks and poles.

By this stage I had decided that the painting would work better with more colour, and I therefore washed colour over the sky and land in the normal way.

Neat Japanese bright yellow was sponged on to the field and blended towards the horizon. I then dabbed on some neat cloeseed yellow and some gouache yellow. Finally, I added some gouache permanent lemon. Once the colour had dried, I added more gouache yellow and more permanent lemon with a wet sponge.

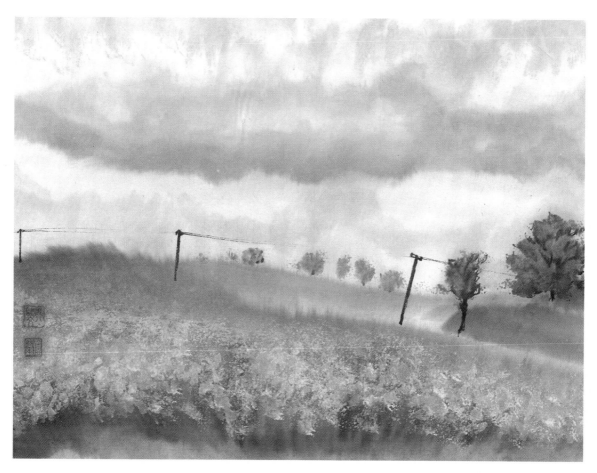

Fig. 85 (ABOVE) *Rape Field, Lincolnshire,* 48 × 66 cm (19 × 26 in)

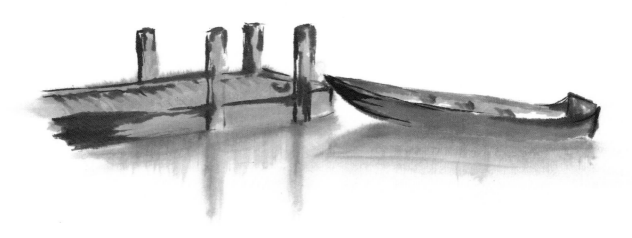

WANDLEBURY, CAMBRIDGESHIRE

Just south of Cambridge are the Gog Magog hills. Local
people are fond of telling visitors that these are the highest
land between Bedford and the Russian Urals. Wandlebury
Ring on the Gogs was the site of an Iron Age fort and a
focus for the surrounding settlements. Nowadays, it is a
well visited local beauty spot. At weekends, the car park
is crammed with cars and the whole area swarms with
children and dogs, and people wearing brightly coloured
anoraks. During the week, it is possible to be there alone
and then it is easier to believe in the Iron Age people and
even to be slightly less incredulous about the theory that
Wandlebury is the site of ancient Troy! (Iman Wilkens,
Where Troy Once Stood, Rider, London, 1990.)

Before painting the picture in **Fig. 86**, I paid a solitary
visit to the area on one of those sticky, sunless, summer
days when a sullen canopy of cloud covers the sun without
relieving the clammy warmth.

Though the Gog Magog hills are, of course, slightly
higher than the surrounding countryside, this particular
scene is itself rather flat and I have therefore included it in
this chapter. Besides, the fact that such a low range of hills
can so dominate the landscape always emphasizes for me
the flatness of the area that I live in!

Fig. 86 *Wandlebury Ring,
Cambridgeshire,
44 × 66 cm (17½ × 26 in)*

Since they are such a major element of the composition, I began by blocking in the shapes of the main group of trees with a small, close-textured, natural sponge. I used the technique described for the leaves of the copper beech in **Fig. 27**. Because I did not begin with a trunk, I was careful to keep the shapes of the trees in mind and I used the darker ink for shadow. The trunks and branches were added in black with a plum blossom brush.

I split the end of a medium semi-coarse brush to add grassy texture to the foreground and to mark the boundary of the field, giving the effect of roughly mown grass. I used mostly tapered strokes along the bristles. The brush was skimmed across the paper to give texture to the far field. Then I added the rest of the trees and left the ink to dry.

I sponged colour on to the trees, adding more indigo for the distant ones. Once this colour had dried, I damped the paper and put a fairly thick colour wash over the foreground field, using a more dilute version of the same colour for the far field. Next I painted the sky.

The far line of trees was made to look slightly less distinct by sponging some of the cloud tone over them. Because I did not want the path to look like water, I decided to blend a little gouache white, toned down with a touch of autumn brown, over it. Neat gouache yellow was sponged on to the field and the flowers were dabbed on with a split brush. Last of all, I added the birds.

THE MASAI MARA

Like many people I enjoy watching wildlife programmes on television and marvel at the skill of the cameramen. However, even the most superbly shot film on a small television screen could not prepare me for the actual magnificence of the Masai Mara Game Reserve in Kenya, the northern tip of the enormous Serengeti Plain. Sometimes its vast expanse seems to teem with literally thousands of animals: giraffe, zebra, wildebeest and impala – all milling around together. At other times it appears almost empty, although, if you look carefully, there are always animals there.

I chose to paint the particular scene in **Fig. 87** mainly because of the vultures sitting in the tree, gazing out over the plain towards the ridge of the Mara hills. The tree was standing alone but its shape is typical of the plain and it was echoed by similar trees in the distance.

I started with the tree, beginning with the colour for the trunk and branches in the manner described for **Figs. 31**

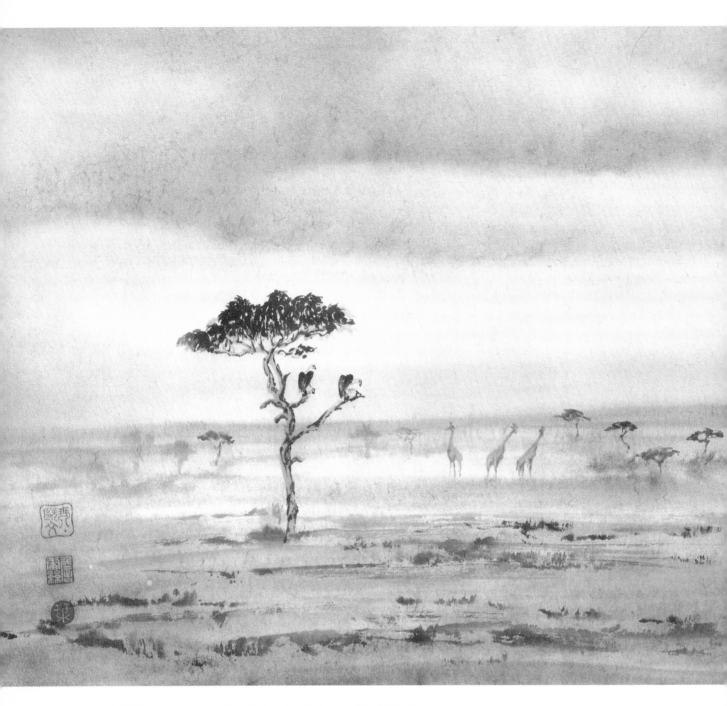

and **32b**, using a small soft brush. I then added black
emphasis. The leaves were stabbed on with the tip of a
small coarse brush, and the same brush was used to paint
the birds. I used the soft brush to put in a few distant trees.
Next, the giraffes and wildebeest were added, using the
method described for the horse in **Fig. 56**.

The foreground texture was done with a large coarse
brush, filled with a mixture of cloeseed yellow, burnt sienna
and autumn brown, and tipped with autumn brown mixed
with black ink. I stroked its full length lightly on to the

Fig. 87 *Masai Mara, Kenya,*
48 × 74 cm (19 × 29 in)

paper several times, across the bristles. The colour tone was
varied slightly with each stroke. Grassy texture was done as
for **Fig. 83**, then extra texture added in black.

As I put on the softer ground textures on damped paper,
I used variations of the same tone and stroked the colour
across the paper to encourage a feeling of width. Then I
put in the ridge.

Finally, I painted the sky by rolling the clouds on to the
paper with a large, soft brush in the manner of **Fig. 71a**,
and bleeding vermillion and white into light areas.

WATER & SKY

水与天

In this chapter I have decided to tackle the two most
changeable elements of any landscape: water and sky. The
appearance of the land itself alters according to season, but
this is a gradual process that occurs from month to month,
not from hour to hour or even moment to moment. More
rapid changes are usually the result of changing weather
– sun, cloud, rain, wind and mist can dramatically affect
the mood of a scene and alter its appearance. Thus water
and sky influence the appearance of a landscape and,
at the same time, provide a striking reflection of the
mood of a scene.

I am fascinated by both these elements. Still water can
be clouded and mysterious, or cool and limpid. Rough
water foams and curls in intricate and unrepeated patterns.
The combination of cloud and light in the sky can often
produce startling, transitory beauty.

Water and sky are therefore important elements in most
of my paintings. However, I have included here only those
paintings in which they are the main theme.

DUNSTANBURGH CASTLE, NORTHUMBERLAND

The painting in **Fig. 88** shows the view of Dunstanburgh
Castle that you get as you approach it along the shore path
from Craster. Today the castle can be reached only on foot.
It stands starkly etched against the sky, remote on a solitary
hill at the eastern end of the Great Whin Sill. Once,
however, a paved causeway crossed a drawbridge over the
ditch separating the castle from the mainland, and ran
inland. The present-day footpath goes over the silted-up
mouth of a natural harbour that was once big enough to
provide shelter for the men-of-war of Henry VIII's fleet.

The castle was begun in 1313 and, in its early years, was
used mainly to defend the Marches from incursions by the
Scots. Through marriage it came into the possession of
John of Gaunt and passed to his son, Henry IV. Thus it

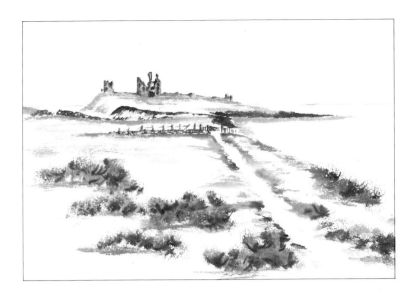

Fig. 88a Stage 1

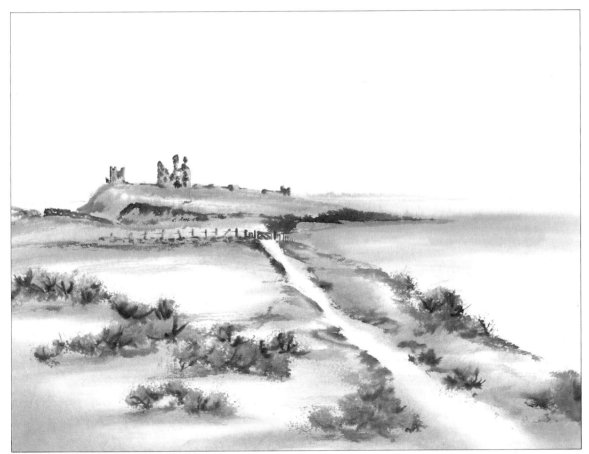

Fig. 88b Stage 2

became a Lancastrian stronghold and saw plenty of action during the Wars of the Roses. The damage done to the castle during the sieges and battles was never repaired and later owners used the castle as a source of building materials for more strategically important fortifications. The sea and the weather completed the task of creating a splendid ruin.

117

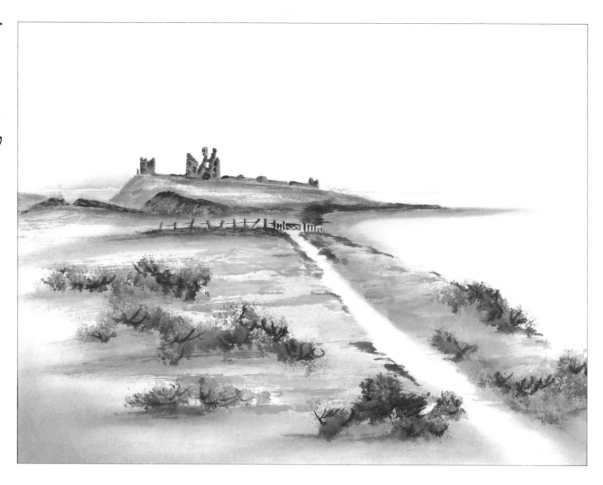

Fig. 88c Stage 3

Today the castle is redolent of its bloody and dramatic history but, at the same time, it now seems to be resting in peaceful harmony with the sea and sky that surround it.

I first saw Dunstanburgh on a spring day that had begun cold and wet. As I set out, the rain stopped, and I watched the sky lightening and the dramatic cloud formations changing. The castle stood out clearly against the horizon and the yellow gorse bushes glowed richly.

For this painting I chose lightly sized Taiwanese cotton paper because it is larger than the 19-in *shuan* and enabled me to make the picture as wide as I liked, at the same time leaving room for a broad expanse of sky. The paper is very white, which added a freshness to the ink and colours that accorded well with the just-washed look of the scene as I remembered it.

First I marked the horizon to make sure that it was level. I made a fold about a third of the way up the paper and marked it with very light ink. So that I did not make the castle too level, I also made a very light line to mark the slope under it. Once the ink had dried I redrew the horizon with a solution of alum, hoping to prevent the sea and sky merging too much later.

118

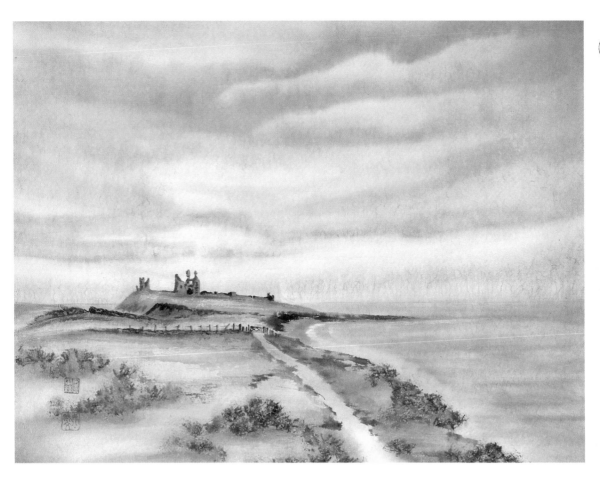

Fig. 88d *Dunstanburgh Castle, Northumberland,* 61.5 × 78.5 cm (24¼ × 31 in): Stage 4

For **Stage 1** (see page 117) I did the castle with an orchid brush, following the method described on page 62. I also put in the fence and gate and the stone walling. Changing to a bamboo brush, I added shape and texture to the ground. I used a small open-textured sponge for the gorse bushes, adding a few branches with the brush.

In **Stage 2** (see page 117) I used a medium semi-soft brush on damped paper to add more shape and texture. To counteract the somewhat erratic spreading of the darker shades, caused by the sizing, I was careful to put only a little ink on at a time and to blend it immediately. In a few areas I left the ink to bleed to create extra texture.

I left the paper to dry before adding colour to the individual elements, and skimming colour lightly over parts of the foreground. (**Stage 3**)

I redamped the paper and ran colour over the land, varying the tone in different areas. The sea was done by the technique described for **Fig. 66**, and the sky by the technique explained in **Fig. 71b**. I used Chinese white as the underlying colour and built up bands of cloud with a large, soft brush. While the paper was still damp, I sponged thick gouache yellow on to the gorse bushes (**Stage 4**).

ANZIO: 1

Fig. 89 *Near Anzio, Italy: 1,* 55 × 46.5 cm (21½ × 18¼ in)

Fig. 89 shows the sea in a calm mood. The scene is the Italian coast a little way outside Anzio where I stayed for a few days in a flat belonging to friends. It was mid-week in spring, out of season; the hotels and restaurants were closed or deserted and my children and I had the block of flats and the beach almost to ourselves. I was convalescing so I spent a lot of time sitting on the balcony which looked out over this view, watching the changing light over the water. In the late afternoon, in this early part of the year, the heat goes out of the sun, and as it moves lower in the sky the colour slowly drains out of the scene, leaving water and sky fused into one. In this painting I was trying to capture this gentle, translucent light at the end of the day.

Because the painting consists mainly of wash it takes comparatively little time to describe the method. It did not, however, take a short time to do. Remember that successful wash effects can be created only by working slowly and carefully and by adding just a little colour at a time.

The hut was put in first, on dry paper, following the method described for **Fig. 46**, and using a plum blossom brush. Once the ink on the building had dried, I ran colour over the roof, walls, stilts and steps. I put a little vermillion into areas that I thought would catch the dying sun.

I then damped the paper and put in the headland and the ruined tower, using a medium soft brush to block in the shape and adding detail with a darker tone. When the paper was almost, but not quite, dry I added finer detail in even darker ink. The paper was then left to dry completely.

Having redamped the paper all over, I put in the sun, following the method described for the moon in **Fig. 69**. Next, I blended colour over the headland and ruin. Then I ran ink and colour over the beach area.

For the horizon, I folded the paper to ensure a level line and ran a mixture of sky blue, indigo and peony purple along it, blending the line outwards.

The water was done with the technique explained for **Fig. 66**, using Chinese white, sky blue and squab red. I put in the ripples and the darker areas of water with the same tone that I used for the horizon, and added the white ripples and the reflection of the sun. The sky was done with very similar colours, following the method for **Fig. 69**.

*Near Anzio, Italy: 2, Early
Morning*, 35 × 48 cm
(13¾ × 19 in)
This shows another view from the
balcony near Anzio. In the early
morning haze of mingling blues
the horizon was almost lost in the
fusion of sea and sky. One misty,
balmy morning, when the sea
was almost totally still and the
sky cloudless, the world looked
newly washed and completely
deserted. Then a solitary motor
boat crossed the water in front
of me, moving in a line parallel
to the horizon and cutting a dark
swathe through the sea.

 When I began this painting
I wondered whether there was
enough in the picture to interest
viewers. Once it was finished,
I felt that it exactly captured the
tranquillity of the scene. I offer
it, therefore, in the spirit of a
traditional Chinese court painter,
as an aid to contemplation.

Dunkirk Harbour, France,
48 × 63 cm (19 × 24¾ in)
I have always been fascinated
by the sight and sound of the
sea crashing against rocks or
harbour walls. However, I
viewed the waves shown in this
painting with some trepidation
as I saw them from the deck of
a ferry that was emerging from
the shelter of port to cross the
Channel! Nevertheless, I found
the combination of late afternoon
light, a windswept sky, rough
water, and the milky foam and
flying spray irresistible.

 In the event, the crossing was
not as uncomfortable as I had
feared. When I considered the
finished painting I realized that
perhaps I had unconsciously
reflected this by making the sea
look less threatening than I had
originally intended!

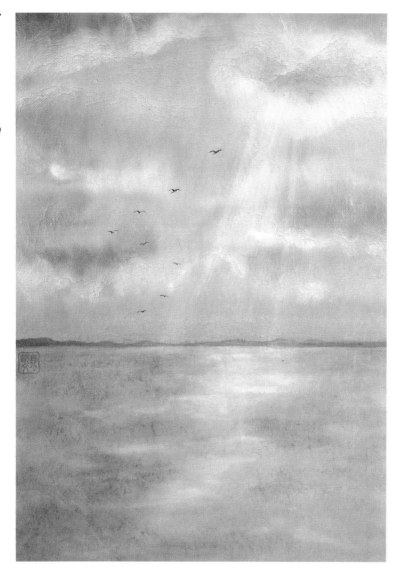

Fig. 90 *The French Coast,*
59 × 42 cm (23¼ × 16½ in)

THE FRENCH COAST

Although I am a reasonable sailor, I prefer to cross the
English Channel in calm weather. However, when
the weather is bad I find great compensation for an
uncomfortable journey by watching the sea and the sky.
Churning seas and stormy skies are fascinating to watch,
altering from moment to moment. The painting in **Fig. 90**
was done after a rough crossing when I had watched the
French coastline disappear as the clouds gathered and the
sea began to heave.

First I marked the horizon lightly in pencil, then damped
the paper evenly and put in the coastline with an ink and
colour mixture. Next, I did the water, using the technique
described for **Fig. 67**, and varying combinations of the
colours that I had used for the land. I did not add the light

area at this stage, because I wanted to be sure to relate this to the light in the sky.

The sky was done by essentially the same method as that explained for **Fig. 71b**. However, I used much more gouache colour than usual, including blues. To make the clouds look dense, I mixed gouache white with ink for the dark grey. I kept the brush very wet, pausing and pressing in places to encourage the colour to bleed. Because the paint was thick, and because I applied it very slowly, the colour formed little ridges, which added extra texture. I used neat gouache white for the lighter clouds. I streaked gouache white downwards where the sun's rays burst through the cloud, using the method described for rain in **Fig. 72**. Then I blended a little gouache white on to the water to create the effect of the light striking the surface. The line of birds following the ferry was added last of all, after the paint had dried.

This painting does not look at all Chinese. Nevertheless, I could not have achieved the effects without using absorbent oriental paper. Here I chose cotton paper because it is very strong when wet. This allowed me to use a lot of very wet colour and to brush over the surface repeatedly without damaging the paper.

North Norfolk Coast, near Weybourne, 42 × 47 cm (16½ × 18½ in)
Invariably, whenever I visit the part of the North Norfolk coast shown here, the weather seems to be grey and wet. This painting is therefore my response to what I, perhaps unfairly, always think of as the essential nature of this particular stretch of stony, cold, English beach. For me this painting sums up a chilly, damp day at the coast, when sky and sea combine in a blanket of wet cloud that muffles the sound of water lapping over the shingle.

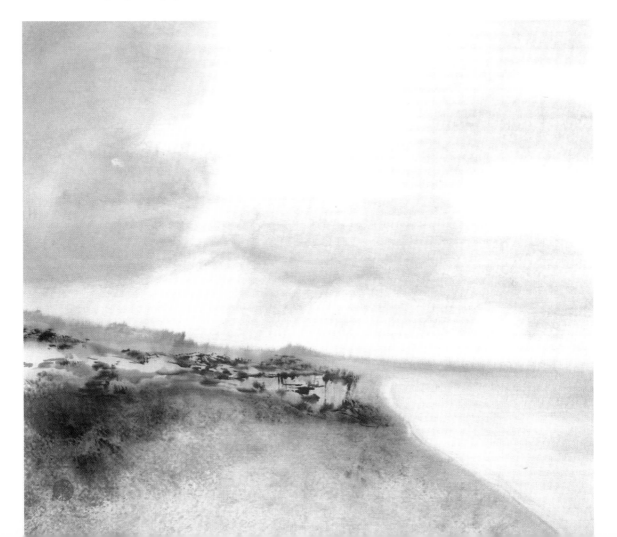

HILLS & MOUNTAINS

丘陵丂高山

The title 'Hills and Mountains' here covers everything
from a jagged, snow-capped peak to a gently rolling hill.
Some mountain scenery is astonishingly beautiful and has
an immediate impact on the viewer: it may take a little
longer to assimilate the charm of softer, undulating
landscape.

It is comparatively easy to make a striking composition
when painting a dramatic scene and I probably enjoy
depicting this kind of scenery more than any other. I love
creating dramatic shapes and textures to evoke the stark
beauty of the Scottish highlands, for example. However,
I also enjoy the challenge of trying to bring out the
gentler, tree-clad charms of the hills of the Haute Loire
in France.

GLEN GOE: 1

My first visit to Glen Coe was made in mid-April, when
there were few people about. In spite of the modern road
and visitors' centre, I was immediately struck by the stark
beauty of this remote place. The forceful scenery evokes
a strong sense of its bloodstained history. Centuries of
inter-clan rivalry, murders and cattle rustling culminated
in the infamous massacre of 1692 when a government
force, led by a Campbell, was ordered to 'putt all [the
Glencoe MacDonalds] to the sword'. By all accounts,
the MacDonalds were a murderous lot, unpopular with
most Scots. The Campbells were blamed for the massacre
but it was the English who had ordered it. Captain
Robert Campbell of Glenlyon, who led the raiding force,
was related to his victims: he and his troops had been
entertained in the homes of the MacDonalds for ten days
before he received his orders. The massacre itself was very
inefficiently carried out. About 38 people were killed but
at least 300 escaped from Glen Coe into the surrounding

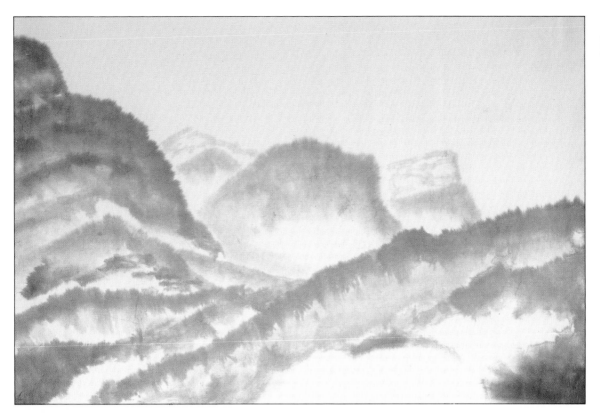

Fig. 91a Stage 1

hills, including the chief's two sons and his grandson. The downfall of the MacDonalds came only later, as a result of their allegiance to the Jacobite cause.

Strictly speaking, Glen Coe is a valley. However, although I would not go so far as to agree with Dorothy Wordsworth when she wrote in her journal that the 'glen was nothing' and the 'mountains were all in all', it was certainly the mountains that occupied my attention when I was painting the picture in **Fig. 91**. As you look at the towering masses looming above the valley, it is easy to understand why the area has more than its fair share of giants and witches. These include Fingal, who is credited with the defeat of the Vikings in Glen Coe, and Bean Nighe, who can be seen washing her clothes in the River Coe by those who are about to die, and who appeared the night before the massacre.

I decided that the most important elements of this scene were the sweep of the hills down into the valley and the looming shapes of the Three Sisters mountains. I therefore began by establishing these in **Stage 1**. I damped the paper evenly and then rolled and pressed the shapes of the hills on to the paper, using a very large soft brush. I kept the brush very wet and encouraged the ink to run. The tip of the brush was used to draw in the grey areas on the snow-covered peaks.

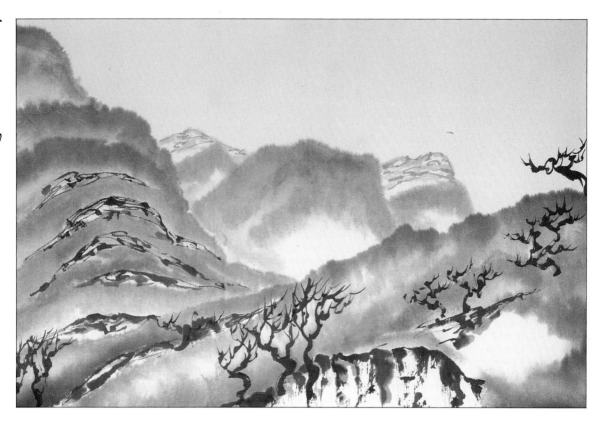

Fig. 91b (ABOVE) Stage 2
Fig. 91c (BELOW) Stage 3

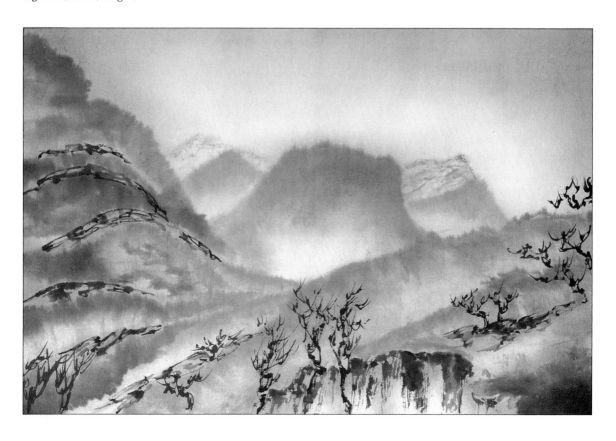

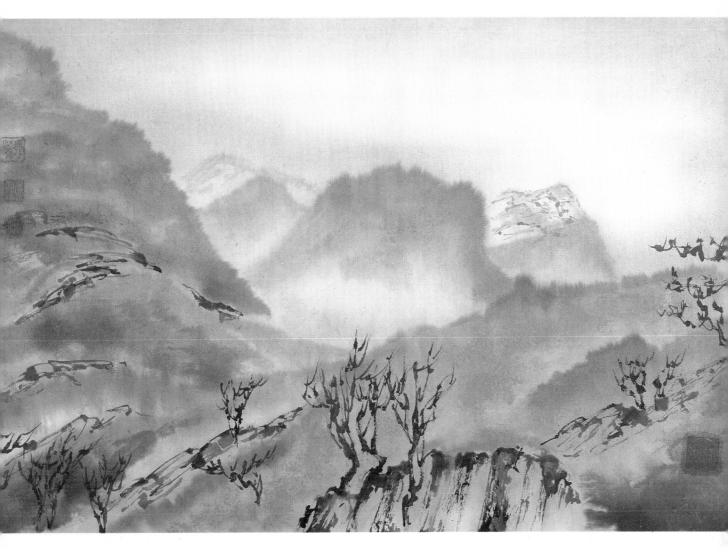

For **Stage 2** I worked the rocky outcrops and the bushes with a medium coarse brush on dry paper.

In **Stage 3**, I redamped the paper and added colour, using a large firm brush and blending with a hake brush. Chinese white was used for the snowy areas. I concentrated the sky colour over the mountains and round the edge of the painting.

I did **Stage 4** immediately, with the paper still damp, blending thick, opaque colour into parts of the rocky outcrops. I then dabbed colour over some of the grassy areas with a small sponge, keeping the sponge wet and squeezing it slightly in places to encourage the colour to run. Using my coarse brush, I added splodges of colour to the bushes and drew in a few extra branches.

Allowing for the drying time between the first two stages, I did this painting very fast. I think this has helped it to retain a vigour which can sometimes be lost when a painting has to go through a great many stages.

Fig. 91d *Glen Coe: 1,*
47 × 72 cm (18½ × 28¼ in):
Stage 4

GLEN COE: 2

The view of Glen Coe seen in **Fig. 92** shows the valley in a different mood, harsher, with the mountains etched sharply against the threatening sky. In this part of the Glen, the greens and browns of the land that I showed in **Fig. 91** have become bleaker tones of yellow and brown. The bushes and grass have given way to scrub and a solitary tree. There is less mist and the snow-covered hills show clearly.

This painting was done on one-ply Chinese *shuan* of the type sold in single sheets. I used this because I wanted a larger sheet than usual so that I could achieve depth as well as width. The paper behaved very like my usual *shuan*, but it is more fragile and I had to take extra care not to tear it or damage its surface.

Using a very large soft brush, I blocked in the foreground on damped paper, rolling and pressing the brush on to the paper to create shape, texture and tonal variation, I added extra black tone in some areas. The river was left clear of ink and a space created for the house.

Next, I blocked in the nearer mountain, using dark ink tones because I wanted the shape to loom over the foreground. I did not blend the ink higher than the snow line because I wanted the mountain to stand out crisply. For that I needed to work on dry paper. I did the more distant mountains in the same way, using lighter tones of ink.

Once the paper had dried, I used a medium coarse brush to put in the black texture in the foreground, changing to a small soft brush for the posts, tree and house. The mountain tops were added in tones of grey. Then I damped the river and ran in a little light ink for the reflection.

Because I had discovered that the paper surface had a tendency to pill, I decided to add the colour wash from the back, so I turned the painting over before redamping it and brushing in colour tones in the usual way. I had to remember to reverse the scene mentally: this was particularly important for the sky. To make the clouds, I followed the technique explained for **Fig. 71a**, using a large soft brush.

Being careful not to tear it, I turned the paper over again. While it was still damp, I added dilute Chinese white for the snow, using my small soft brush, and put gouache white on the house. I blended thick, opaque colour on to small areas of the rockier-looking parts of foreground, then added a little neat Japanese light green to the same areas.

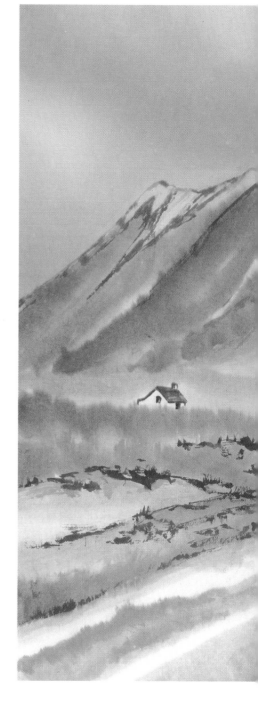

Fig. 92 *Glen Coe: 2*,
60.5 × 84 cm (23¾ × 33 in)

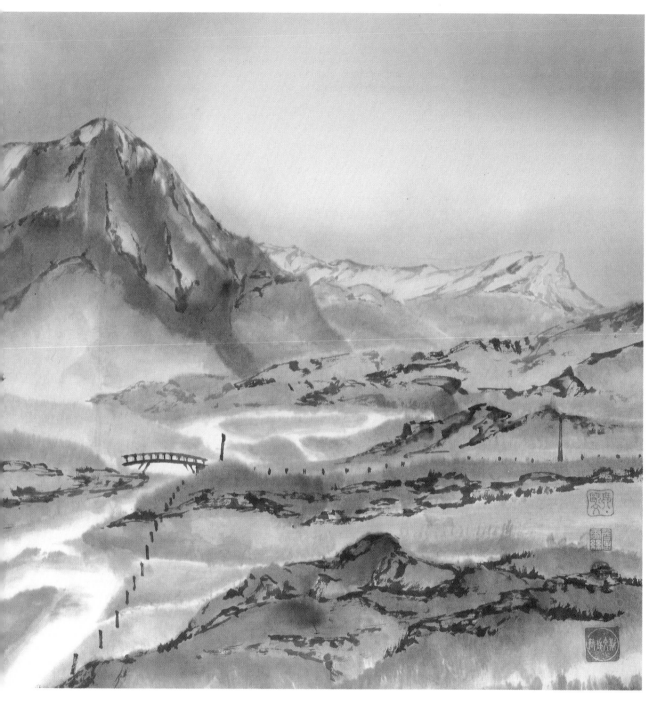

QUARRY NEAR HALTWHISTLE, NORTHUMBERLAND

One April day I was standing in an icy wind with cold rain stinging my face, looking along Hadrian's Wall. It was only too easy to believe in the apocryphal Roman general who is reputed to have peered northwards through the murk, declared the barbarians welcome to such inhospitable country, and decided to bring the Roman Empire to a final border then and there!

In fact, of course, the wall was built along a natural escarpment, the Great Whin Sill, which crosses the narrowest neck of Britain. It was garrisoned mostly by locally recruited troops, who must have been inured to the climate to some extent. Even so, it is easy to imagine how bleak and bitter life must have been for those Roman soldiers. The winter version of a legionary's uniform, on display in the Roman Army Museum, made me shiver to look at it, and the model of the barracks on display showed little evidence of the famous Roman central heating.

The painting in **Fig. 93** shows the Great Whin Sill in the distance and a man-made quarry in the foreground. The scene was made up of a variety of textures and I used this painting to experiment with different ways of achieving them.

Using a medium coarse brush, I put in the foreground bank, rocky outcrops, posts, bushes and fallen tree, adding grey texture for the grassier areas. I laid a sheet of smooth cartridge paper under the *shuan*, lifted the bottom right-hand corner of the painting and sloshed wet grey paint over an area of the cartridge paper roughly the same shape as the grassy part of the bank. As I pressed the *shuan* down on to the cartridge paper, slightly speckled grey patches appeared on the bank. I then removed the cartridge paper.

The quarry wall was done with the same coarse brush, then the bank above the quarry side and the row of fence posts were put in.

I used a screwed-up piece of kitchen paper in the same way as a sponge to apply the spiky, dry texture for the bushes on the quarry floor. Because this soaked up a great deal of moisture, I had to make a lot of grey ink. Next, I dipped the same wad of paper into thick black ink and repeated the process. The trunks and branches were added in black, using a small coarse brush.

Once the ink had dried, I drew in the wire and added some branches to the bushes, experimenting with a white wax crayon as a resist. Although it worked well, in that the white shows clearly through all the colour put over it,

it was brighter than I wanted. I decided later that I could have achieved a similar effect by adding gouache white after the colour wash.

The painting was damped evenly before being laid carefully over dry cartridge paper. I added some texture to the quarry floor by printing it from the cartridge paper as before. Because the *shuan* was damp it picked up more of the grey ink and created a smoother texture than before.

I also printed the trees on the right of the painting, gently lifting the *shuan* and dabbing wet grey ink on to the cartridge paper with a small open-textured sponge. The trunks were drawn on to the cartridge paper with a wet brush and the *shuan* was pressed down as before. I repeated this process several times to make the trees look dense, then retouched the trunks slightly.

I decided that it would be too difficult to position the trees round the buildings by printing them, so I removed the cartridge paper and did these in the usual way. At this stage I added the buildings.

This part of Northumberland is criss-crossed with dry-stone walls. Because the weather was so murky, these showed up merely as dark gashes, dividing the fields. I indicated the walls by running dark ink lines into the

Fig. 93 *Quarry near Haltwhistle, Northumberland*, 48 × 90 cm (19 × 35½ in)

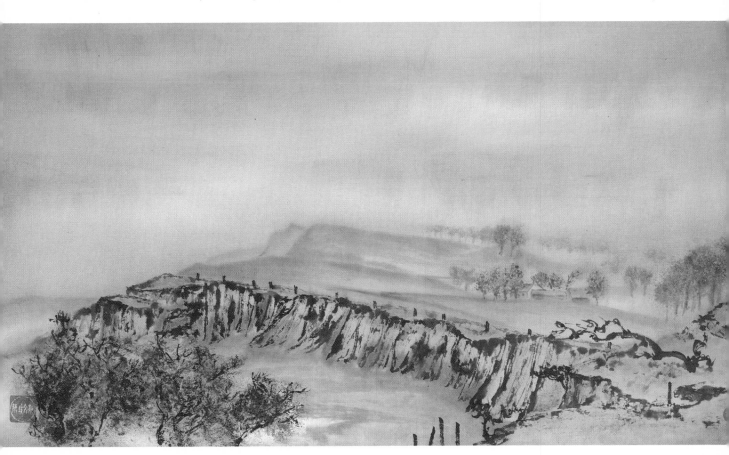

paper with the larger coarse brush. Next, I added the more distant grassy banks and the Sill, rolling these on to the paper with a large firm brush, in the manner described for **Fig. 45b**.

Once the painting had dried I relaid it over the cartridge paper. This time I sloshed wet colour over an area of cartridge paper corresponding to the grassy bank before pressing down as before, and then removed the cartridge paper. Next, I dabbed colour over the bushes with my wad of kitchen paper.

I allowed the colour to dry before damping the paper evenly all over. Colour was printed over the quarry floor, using the cartridge paper underlay again. The cartridge paper was removed before colour was blended over the grassy areas of the foreground. Next, I ran colour over the rocks and quarry wall, applying it unevenly and blending it with a hake brush, and then put on the rest of the colours.

Once the paper had dried, thick colour was dabbed on to the bushes with screwed-up kitchen paper. I printed opaque texture on to the trees on the right of the picture, using a cassette lid and printing from the front, as I did for **Fig. 73**.

Hills near Fort William, Scotland, 66 × 48 cm (26 × 19 in) Everywhere you go in the Scottish Highlands you are confronted by stunning scenery. You can stand in one spot and see two or three eminently paintable scenes. You can walk down the road and see four more. When I was trying to decide which scenes I wanted to turn into paintings, I found that I was especially drawn to the one depicted here. It is nowhere particularly special; the view is from the road just outside Fort William. I was attracted by the way the mist came down over the mountain and blended with the snow. I loved the rich array of colours; the dark blue-green of the distant trees, the light greens, browns and yellows in the foreground. I also liked the way the house nestled at the foot of the mountain and the contrast between the dark trees and the light ones.

Fort William has a reputation for being the wettest place in Britain. It certainly lived up to this during the few days I spent there in early April. I hope I have managed to convey the pervading chilly dampness of the low cloud and mist, and how this throws the rich colours of the land into sharp relief.

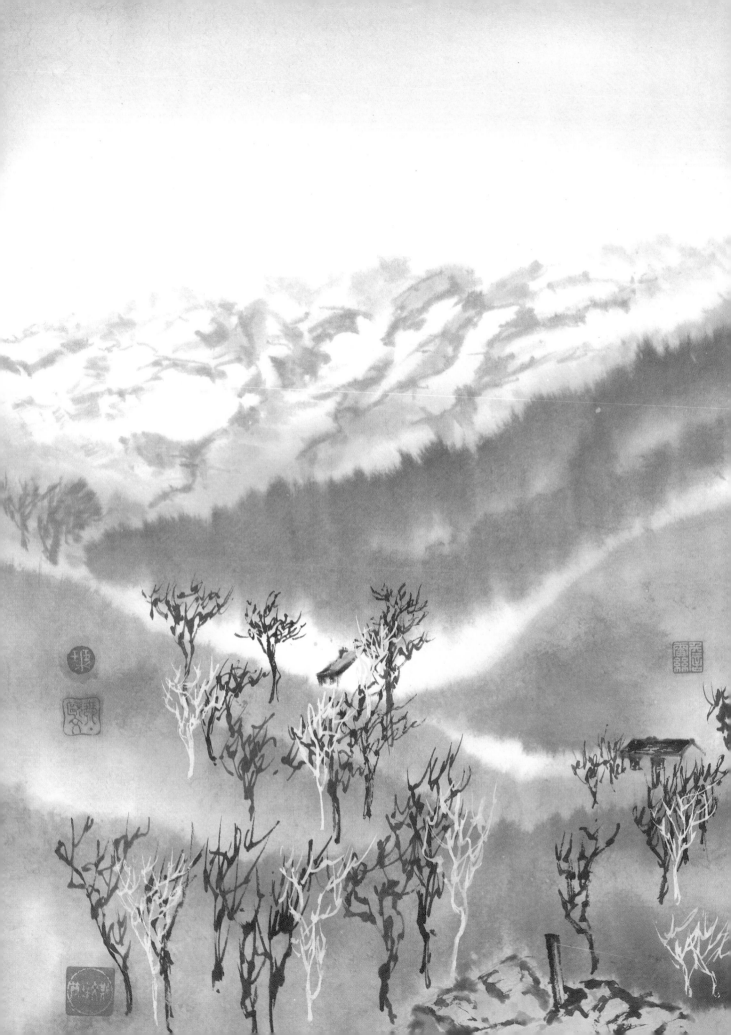

LOCH DUICH

The painting in **Fig. 94** is another attempt to do justice to the beauty of the Scottish Highlands. I found this scene in the early afternoon, when the dank and dismal weather seemed to emphasize the rich colours and enhance the dramatic shapes. This is another easily accessible view that I came on by chance when travelling by road.

Because I wanted the birch trees to stand out, I drew the trunks in with a strong alum solution before I did anything else, using a small soft brush and working out where the lighter trees would be. I also added a few light trunks for the pine trees on the right of the picture.

Once the alum had dried, the paper was damped evenly all over. I rolled and pressed the foreground and hills on to the paper in the usual way. The effect of tall trees on

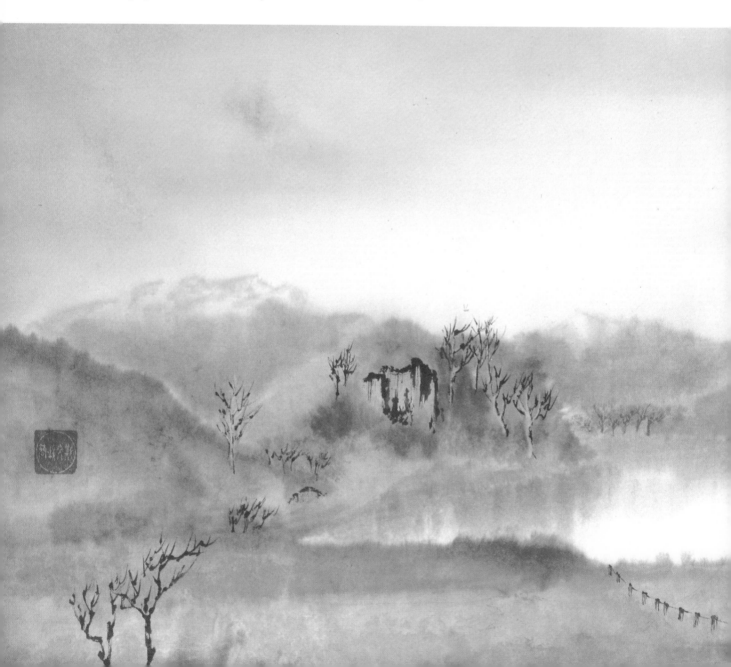

the hill on the right was created by repeatedly pressing the brush-head vertically on to the paper and lifting it off cleanly. Much of the texture on the ground was created by putting the ink on very wet and allowing it to bleed slightly. While the paper was still damp, I made various colour combinations and bled these into parts of the land, creating texture by encouraging the colour to run and puddle.

When the paper was dry I drew in the house. The rock texture was created with a small coarse brush. I picked along the edge of the alum-created tree shapes with black, as I did for the birch tree in **Fig. 28**. Then I put on the colour wash in the usual way, but I washed a little dilute Chinese white over the tops of the far mountains where they were shrouded in mist. Lastly, I sponged a thick mixture of gouache colours over the foreshore.

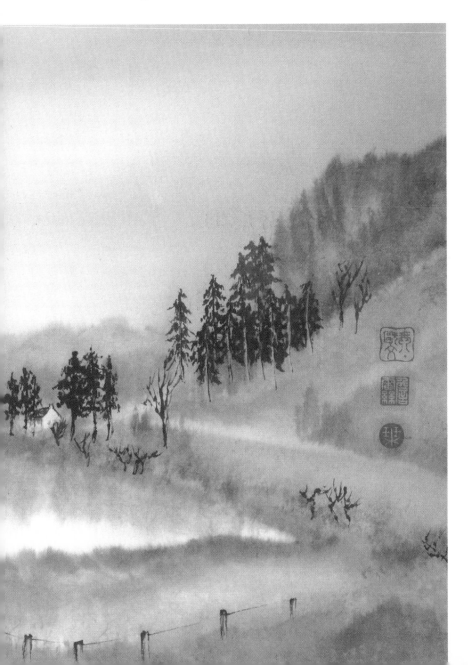

Fig. 94 *Loch Duich, Scotland,* 48 × 85 cm (19 × 33½ in)

MOUNTING & PRESENTATION

裱裝与展示

By now you will have discovered how versatile and adaptable oriental painting paper is. However, it can be rather flimsy and, by the time you have finished a painting, it may be looking somewhat bedraggled. You can remove the creases by ironing the picture on the wrong side with a very cool iron. However, because most oriental paper picks up tone from whatever is behind it, to bring the ink and colours fully to life, as well as to stretch and strengthen a painting, you need to back it with another sheet of paper or with white card.

Backing paper or board

Traditionally, Chinese paintings are mounted on to several sheets of special *shuan*. You can use ordinary good-quality *shuan* but in this case you will need to repeat the backing process several times to build up sufficient strength. You can also use heavyweight decorator's lining paper, preferably the cotton-backed variety, or watercolour paper that is marked 140 lb or more. It is also possible to use thin, acid-free mounting board, but this is less easy to use and I do not recommend it for any but very small paintings. I normally use either watercolour paper or cotton-backed lining paper.

Glue

You can use commercial wheat-based wallpaper paste to stick your paintings, mixed to a loose 'dropping' consistency. However, it is preferable and very simple to make your own glue according to a time-honoured Chinese recipe. Use ten measures of water to one of cornflour. Boil nine-tenths of the water and dissolve a pinch of alum in it. Dissolve the cornflour in the remaining water and add to the boiling water. Simmer the mixture, stirring continuously, until it becomes smooth and glutinous. Stop stirring but continue simmering until the mixture goes clear. Leave to cool.

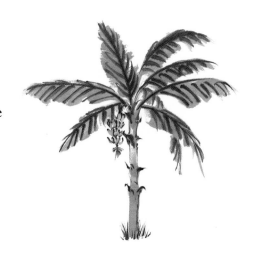

*Le Château de Rochebonne,
Ardèche, France,* 88.5 × 48 cm
(34¾ × 19 in)

The builders of this now ruined
castle were right to celebrate its
spectacular situation overlooking
the valley of the Eyrieux by
naming it for the dramatic rocky
outcrop that it sits upon.

Just as it is sometimes possible
to make an attractive painting
out of an unpromising piece of
landscape, so, quite often, some
very beautiful scenes do not
work well as paintings. Beneath
the castle there is an interesting
huddle of old buildings, ruins
and ancient terracing running
down into the valley. When I
first painted the scene I included
these because they added to the
charm of the area. However,
the painting was too busy and
I had lost the dramatic effect of
the towering rock with the ruins
seeming to grow out of it. The
painting was worked entirely with
soft brushes.

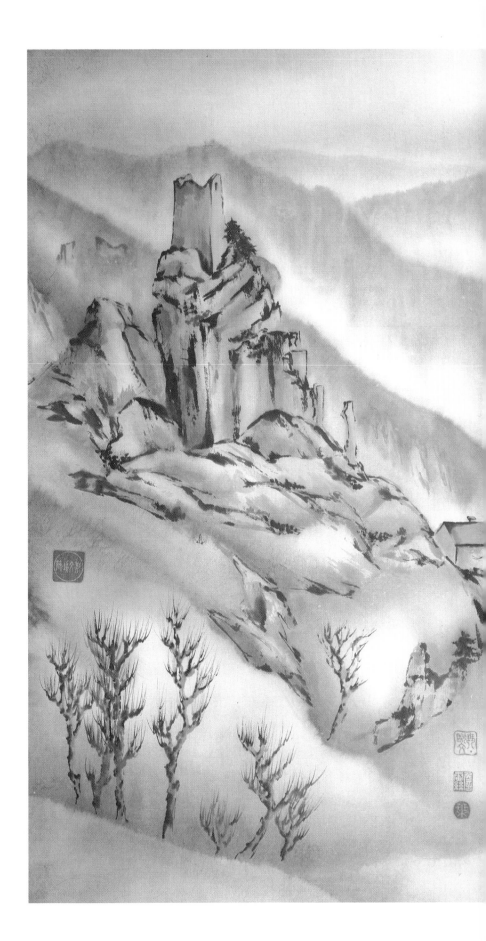

Mounting brush

You will also need a 3 cm (1¼ in) or 4 cm (1½ in) mounting brush. Shops specializing in Chinese brush painting equipment usually stock these, or you can use a Daler-Rowney 38 mm (1½ in) bristle brush. You can use a hake brush, although it is really too soft. An ordinary household paint brush would do, at a pinch, but it is rather too stiff and needs to be used with great care.

Mounting technique

Whichever backing material you choose, you must cut a sheet at least 5 cm (2 in) larger all round than the painting you want to mount. Place your painting face down on a clean, easily wiped surface, such as a Formica table. At this stage it is helpful to spray the picture, especially a large one, lightly all over with water. This makes it easier to work the creases out as you apply the glue.

Brush the glue on to the back of the painting, beginning at the centre and working outwards. Work slowly, adding a little glue at a time and easing the paper very gradually. Gently work out creases and air bubbles. It is very important that no air is trapped between the painting and the table top.

You may sometimes find small creases in handmade *shuan* that were obviously created when the paper was manufactured. These may not always come out easily and it is better to leave them than to risk a tear.

Once your painting is properly glued, wipe off any excess that has spread on to the table. Place the centre of your backing sheet on the centre of your painting, then smooth the backing firmly on to the picture, again working outwards from the middle. I press the paper into place with my hands and then use a long, heavy, smooth wooden paperweight to go over it again, making sure I push out any excess glue or air. Once you are satisfied that the backing is properly stuck, lift one end of the paper and check that the painting will come with it. Peel the paper off the table with the picture stuck to it. Lay the painting face up and check the surface for air bubbles. If there are any, gingerly ease them out from the front with a dry hake brush.

Your picture needs to dry as flat as possible. If you are backing it with *shuan*, you will need to use the traditional Chinese method for this. With the painting face up, paste the portion of backing paper round the edge of the picture. Then place the painting, face first, against a smooth vertical wall and stick the pasted border down. Create an air cushion between the wall and the picture by inserting a small straw and blowing into it. Once the painting has

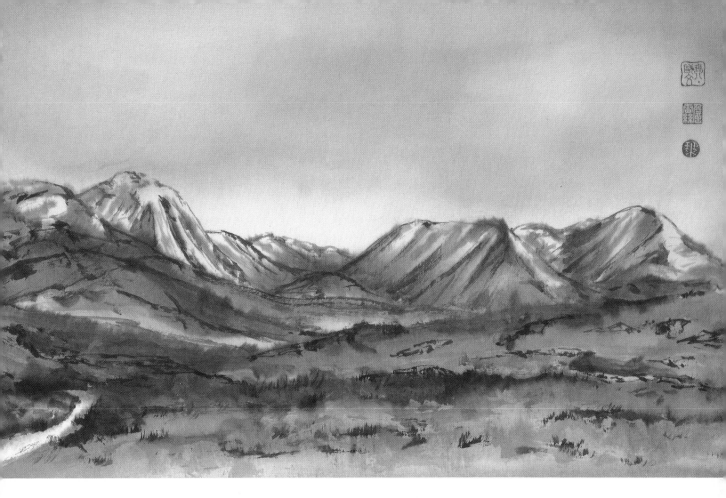

dried, peel it carefully off the wall. Paintings on silk must be dried this way.

If you have used lining paper, trim the excess backing to about 1 cm (½ in) all round. Lay the painting face up on a flat surface and place weights round the edge. When the picture is dry, remove the weights and trim off the rest of the excess backing.

If you have backed your painting with watercolour paper, trim off all the excess backing immediately, otherwise the painting will buckle. Then simply lay the painting flat. Once it is dry, remove any unevenness by placing it under a sheet of board stacked with weights.

It is possible to have your paintings mounted professionally by people who specialize in mounting oriental paintings in the traditional way. Also, most framing shops can dry mount paintings on to board for you. Personally, I think this makes them look stiff and slightly lifeless, but it certainly ensures no tears, creases or air bubbles. However, mounting a painting yourself gives you a satisfying feeling of having finished it properly.

Most problems with mounting are caused by using the wrong materials. Paper that is too thin or non-absorbent will wrinkle badly. Glue must not be too thick or too thin. Above all, you must work carefully and methodically, without hurrying.

Rannoch Moor, Scotland, 48 × 104 cm (19 × 41 in) '. . . God-forgotten, man-forsworn, wild Rannoch . . .' (Neil Munro, *The New Road*, Blackwood) seems a fair description of this harsh, unforgiving gateway to the Highlands beyond. To try to capture the primitive drama of this high moor, I worked all the land on dry paper with a very large brush, to minimize blurring and to ensure that my ink tones stayed crisp and dark. The only time that I damped the paper was for the sky wash and to add extra shading to the land.

Presentation

Traditionally, Chinese landscape paintings are mounted on a scroll. There are two kinds: hanging scrolls for display, and narrative scrolls which are intended to be unrolled and looked at a bit at a time. Making hanging scrolls is a skilled process governed by a great many rules and centuries of tradition, covering everything from the colours of the silk surrounds to the kind of wood used for the baton. Traditionally, a Chinese hanging scroll has the widest band of silk above the painting, representing heaven; a slightly narrower, earth, band beneath the picture, and very narrow side bands. Artists often paint four versions of a scene, one for each season, so that each can be hung at the appropriate time of the year. Narrative landscape scrolls are very long and usually recount a story, typically that of a journey made by an emperor or other notable person. If you want to have a painting scrolled, do not back it. Send or take it to an expert who will first back it with the correct *shuan*.

I prefer to have my own pictures framed because my landscape paintings are of Western scenes and I often use Western perspective and light values. Also, it is worth bearing in mind that, if you are interested in selling your work, the interiors of Western houses are seldom suitable for displaying scrolls satisfactorily.

'Le Fromental', Haute Loire, France, 47 × 89 cm (18½ × 35 in)
This painting shows the view from the hill above the house in the foreground, from which the picture takes its name. The house is a converted farm near Versilhac in the Haute Loire, where I stayed with my family in the summer of 1989. This part of the Massif Central is a stunningly beautiful region of mountains and forests, interspersed with characteristic, conical peaks of volcanic origin, known as *sucs*.

In this painting I was trying to convey the atmosphere early in a summer's evening after rain. The clouds begin to roll away, leaving a chill in the air and mist clinging to the valleys.

This painting was done after my first visit to the Haute Loire. However, since then I have been back to the area several times in different seasons. Having come to know the area well in its many moods, I am happy to find that the picture continues to express my feelings about this outstandingly beautiful part of France.

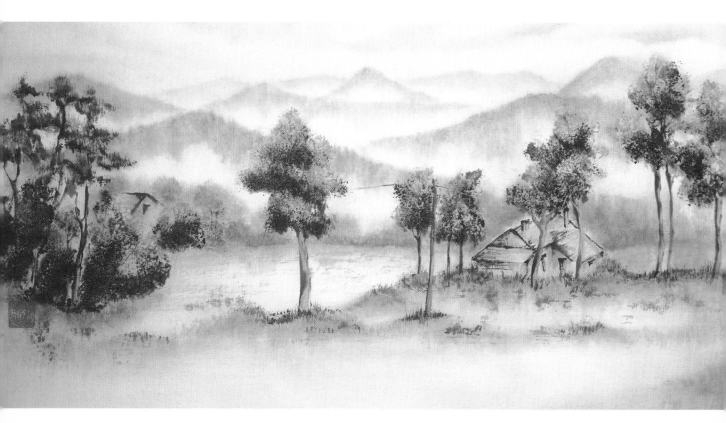

BIBLIOGRAPHY

参考著作名目

The following list of books is intended to provide suggestions for further reading for people interested in finding out more about traditional Chinese landscape painting, as well as for those who want to learn painting techniques.

Au Ho-nien, *Ink and Colour Paintings of Au Ho-nien*, Art Book Co. Ltd, Taipei, 1984.

Cahill, James, *Chinese Painting*, Skira, Geneva, 1977 and Macmillan London Ltd, London and Basingstoke, 1977.

Diao Xirui, *Landscape Painting*, translated by Ouyang Caiwei, Hai Feng Publishing Co. Ltd, Hong Kong, 1989.

Evans, Jane, *Chinese Brush Painting: A complete course in traditional and modern techniques*, Collins, London, 1987 and Watson-Guptill, New York, 1987.

Ho Huai-Shuo, *Inner Realms of Ho Huai-Shuo*, Hibiya Co. Ltd, Hong Kong, 1981.

Hua Junwu (ed.), *Contemporary Chinese Painting*, New World Press, Beijing, 1983.

Kwo Da-Wei, *Chinese Brushwork – Its History, Aesthetics and Techniques*, Allanheld & Schram, Montclair, 1981 and George Prior, London, 1981.

Lao Tsu, *Tao Te Ching*, translated by Gia-Fu Feng and Jane English, Wildwood House Ltd, London, 1973.

Lebold Cohen, Joan, *The New Chinese Painting 1949–1986*, Harry N. Abrams Inc., 1987.

Li Chu-tsing, *Trends in Modern Chinese Painting*, Artibus Asiae Publishers, Ascona, Switzerland, 1979.

Li Xiongcai's *Landscape Painting Manual*, Lingnan Art Publishing House, Joint Publishing Co., Hong Kong, 1984.

Lim, Lucy (organizer), *Contemporary Chinese Painting – An Exhibition from the People's Republic of China*, The Chinese Culture Foundation of San Francisco, 1983.

March, Benjamin, *Some Technical Terms of Chinese Painting*, Paragon Book Reprint Corporation, New York, 1969.

Moss, Hugh, *Some Recent Developments in Twentieth Century Chinese Painting: A Personal View*, Umbrella, Hong Kong, 1982.

Rawson, Philip & Leǵeza, Laszlo, *Tao – The Chinese Philosophy of Time and Change*, Thames & Hudson, London, 1973.

Sullivan, Michael, *Chinese Landscape Painting – in the Sui and T'ang Dynasties*, University of California Press, Berkely, Los Angeles and London, 1980.
Symbols of Eternity – The Art of Landscape Painting in China, Clarendon Press, Oxford, 1979.

Van Briessen, Fritz, *The Way of the Brush – Painting Techniques of China and Japan*, Charles E. Tuttle Company, Rutland, Vermont and Tokyo, 1962.

Wang, C. C., *Mountains of the Mind – The Landscapes of C. C. Wang*, Arthur M. Sackler Foundation, Washington DC, 1977.

Wong, Frederick, *Oriental Watercolor Techniques*, Watson-Guptill, New York, 1977 and Pitman Publishing, London, 1977.

LIST OF STOCKISTS

用品供應商家名單

Materials and equipment

A great many shops sell equipment and materials for Chinese brush painting. Listed below are a few which carry a full and varied range.

HONG KONG

Man Luen Choon
29–35 Wing Kut Street
Harvest Building
2nd Floor, Flat B
Hong Kong
MAIL ORDER AVAILABLE

LONDON

China Art Cultural Centre
32 Parker Street
London WC2B 5PH
071–831 5888
MAIL ORDER AVAILABLE
WILL CARVE CHOPS

Guanghwa Company
7–9 Newport Place
London WC2H 7JR
071–437 3737
MAIL ORDER AVAILABLE
WILL CARVE CHOPS

Neal Street East
5–7 Neal Street
London WC2H 9PU
071–240 0135

REGIONS

Chinese Art Centre
50 High Street
Oxford OX1 4AS
0865 242167

Frank Herring
27 High West Street
Dorchester DT1 1UP
0305 264449
MAIL ORDER AVAILABLE

Guangming Company
22 Berry Street
Liverpool L1 4JF
051–708 9235

Jennifer Scott
Coach Hill House
Burley Street
Nr Ringwood
Hants BH24 4HN
04253 3361
MAIL ORDER ONLY

Samarkand Gifts
31 Elm Hill
Norwich NR3 1HG
0603 623344

In addition, most good art materials shops in the UK carry some Chinese brush painting equipment, and usually can be persuaded to order more. **Inscribe Ltd** supplies a fairly good range of materials readily available in art shops. Some shops selling Chinese giftware may also carry a limited range of painting equipment, as do branches of SOS Children's Villages.